Final Figure

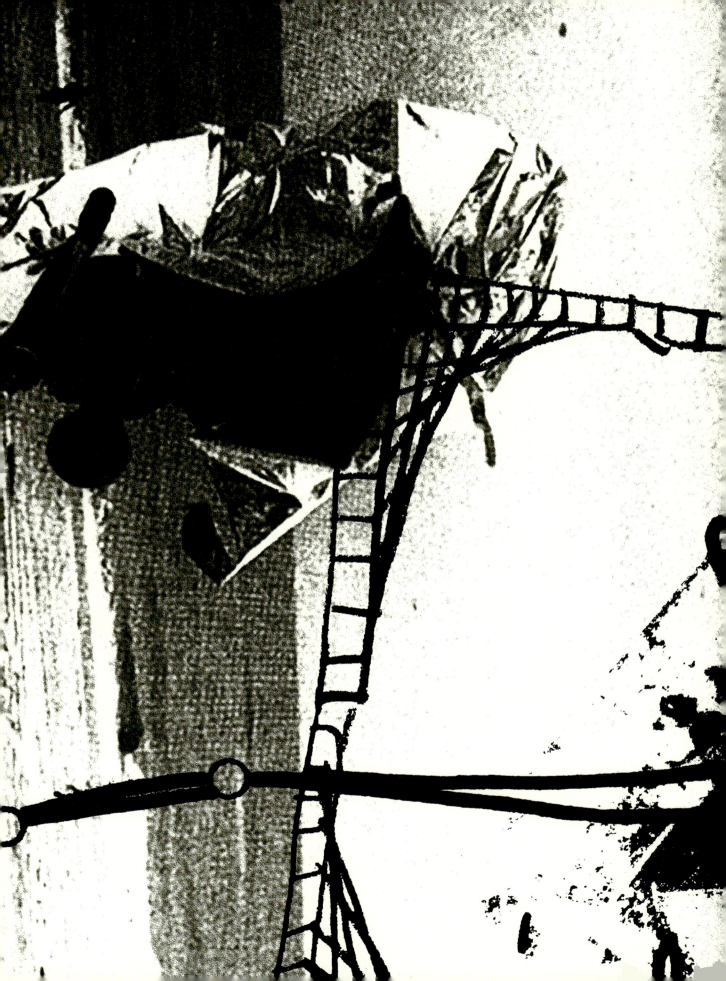

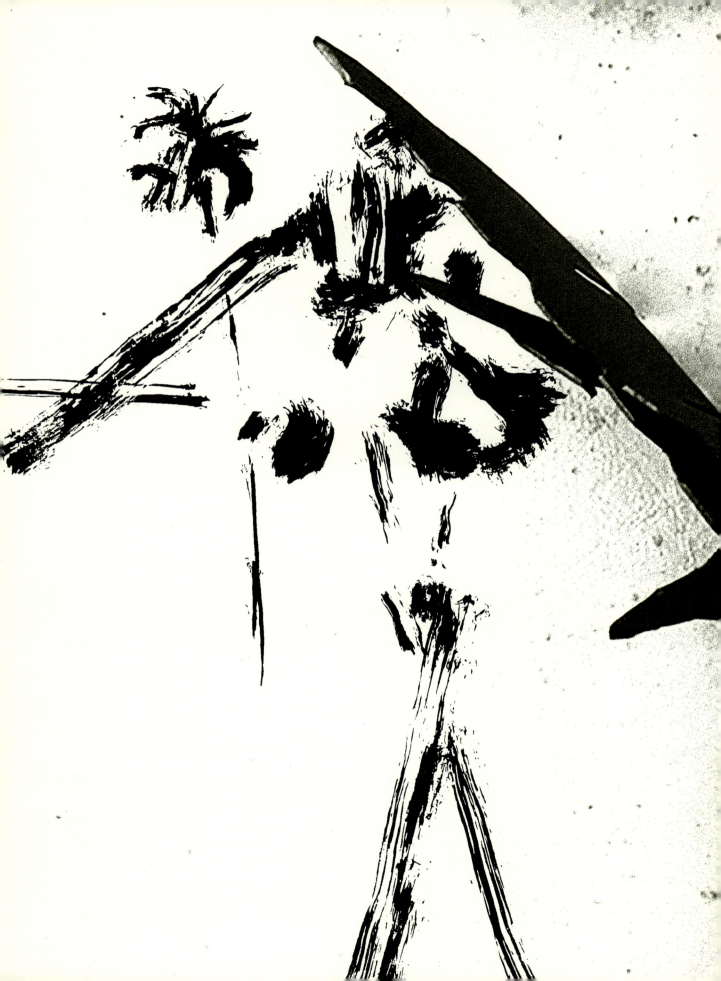

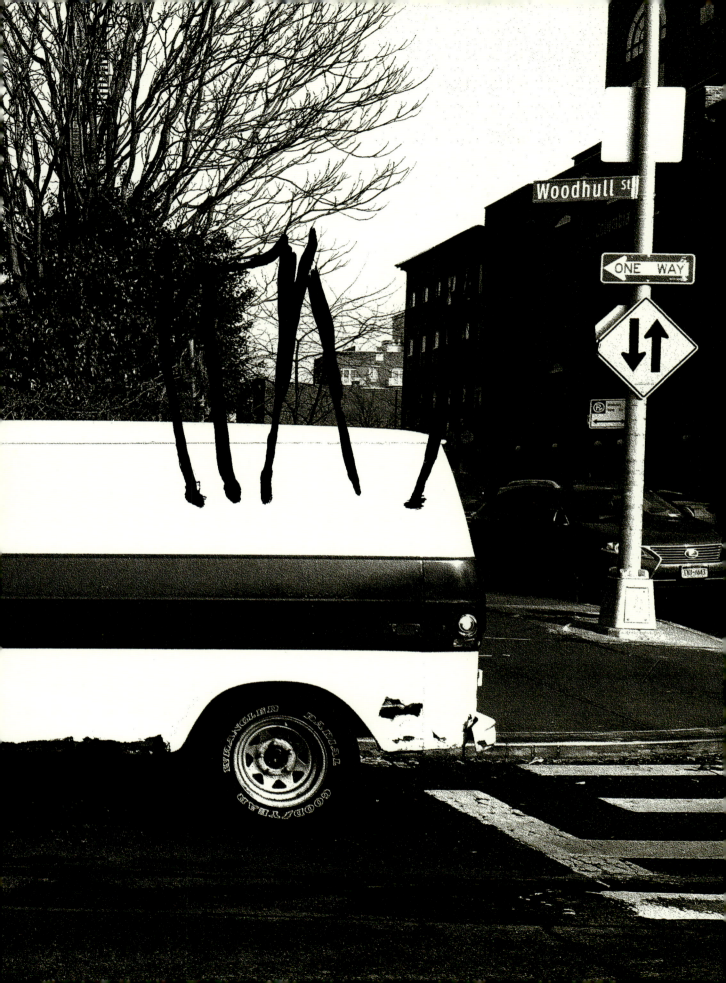

7 Pablo Picasso, *La M. . . .*

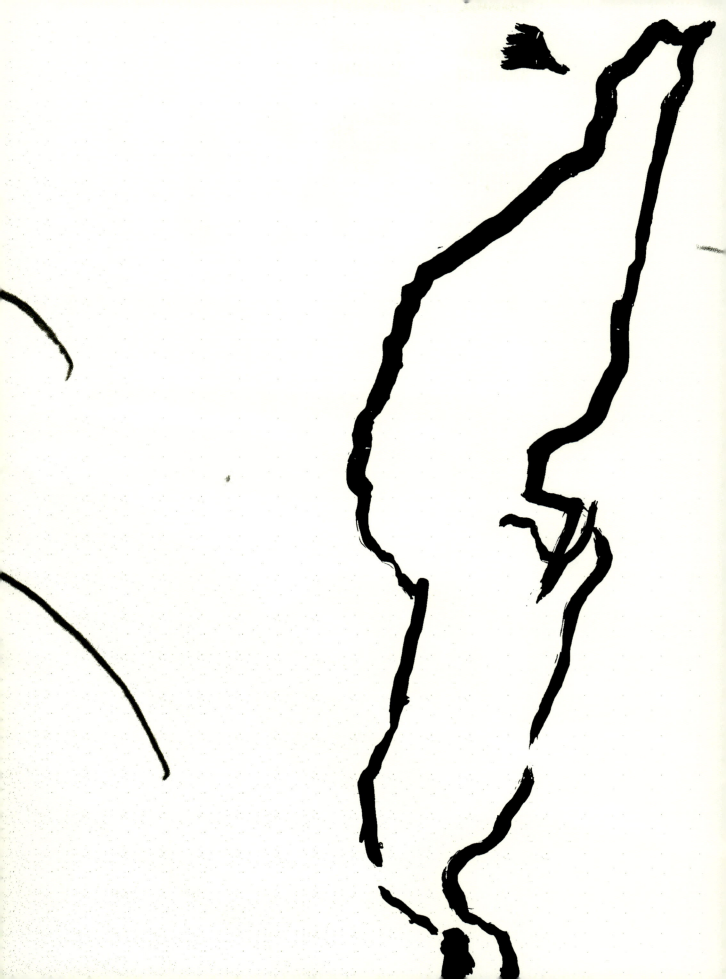

Dhaka Medical College Hospital is wher

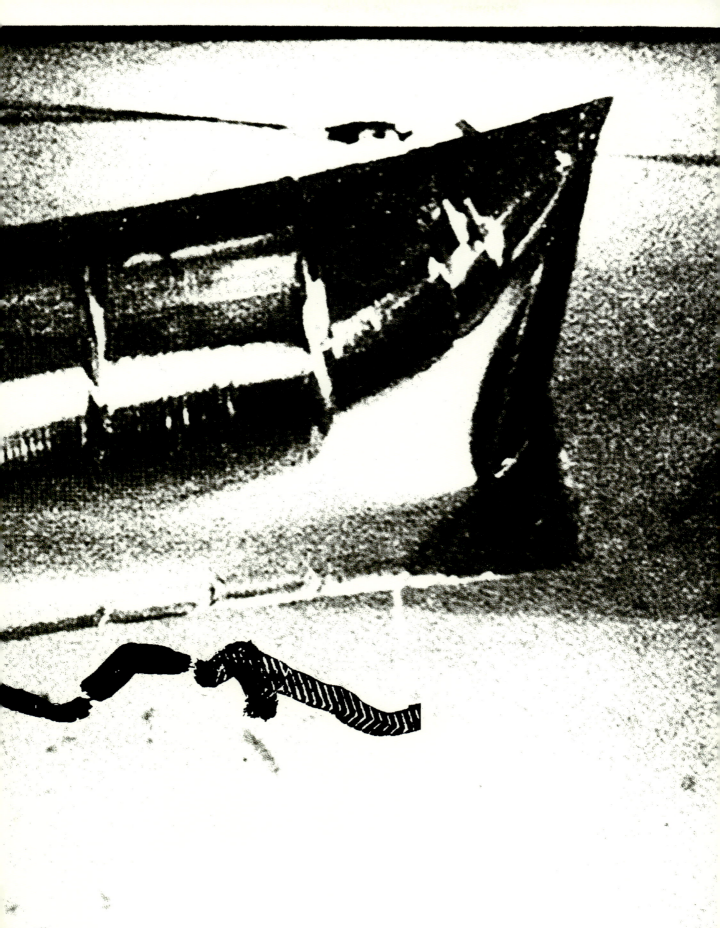

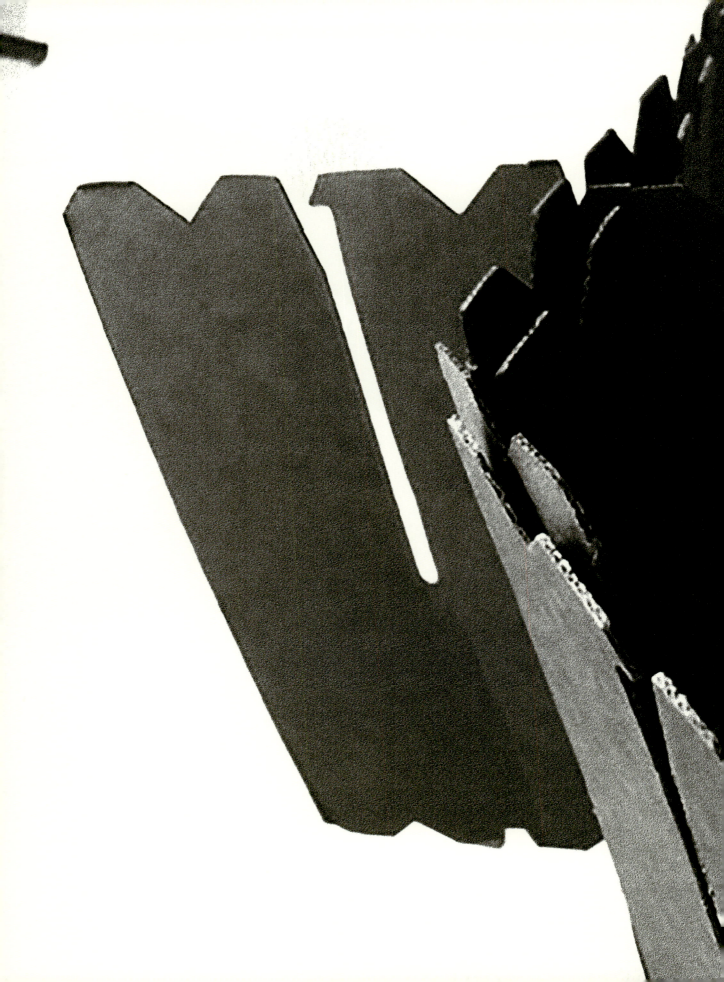

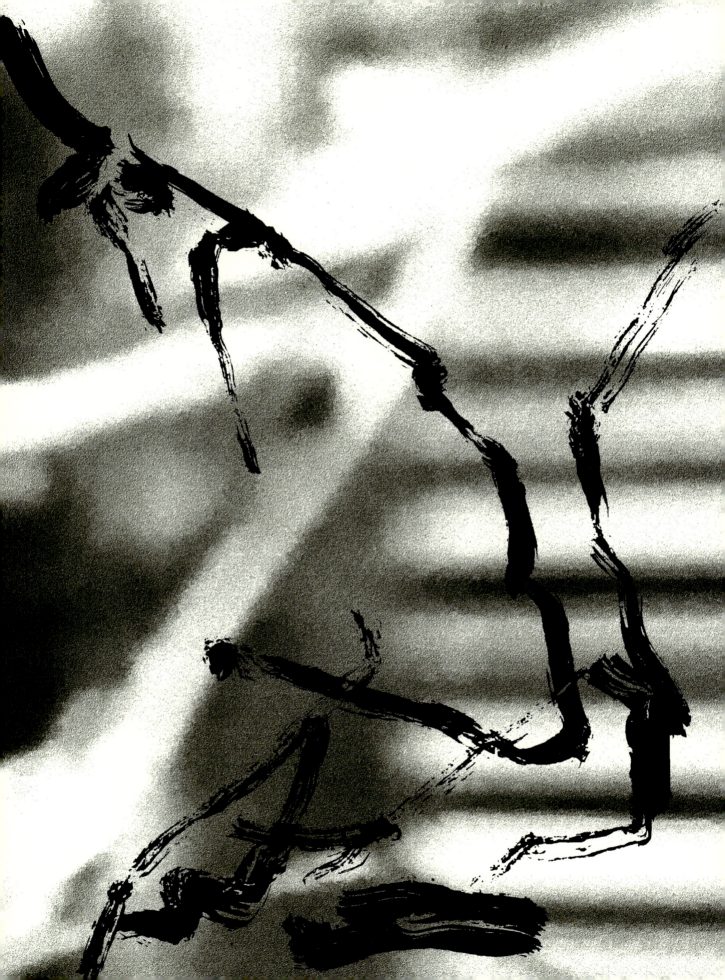

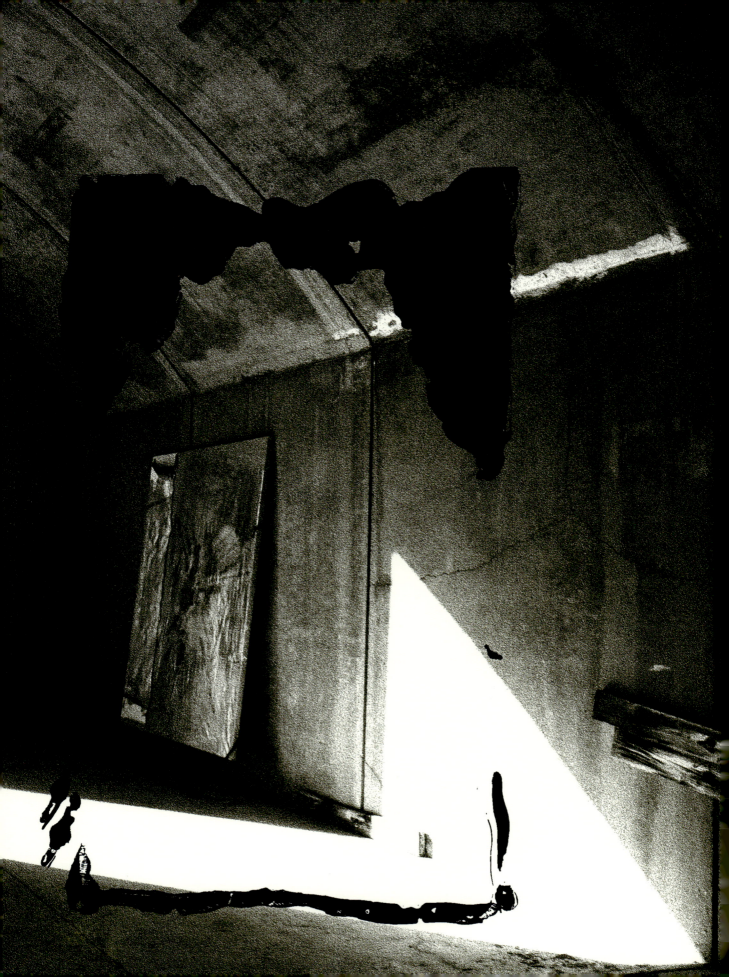

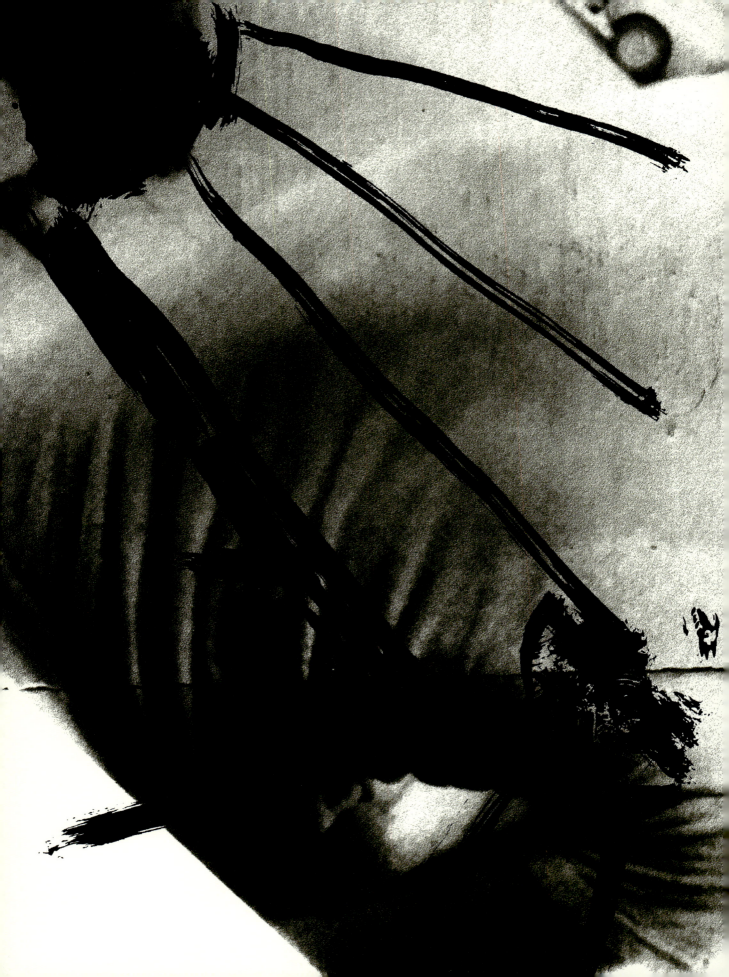

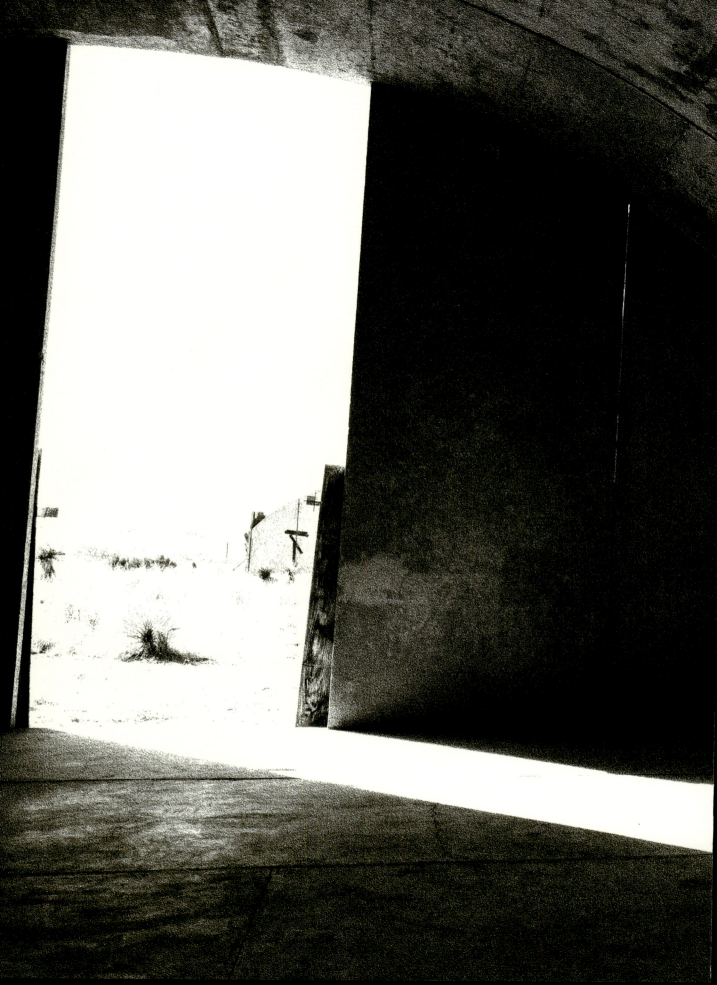

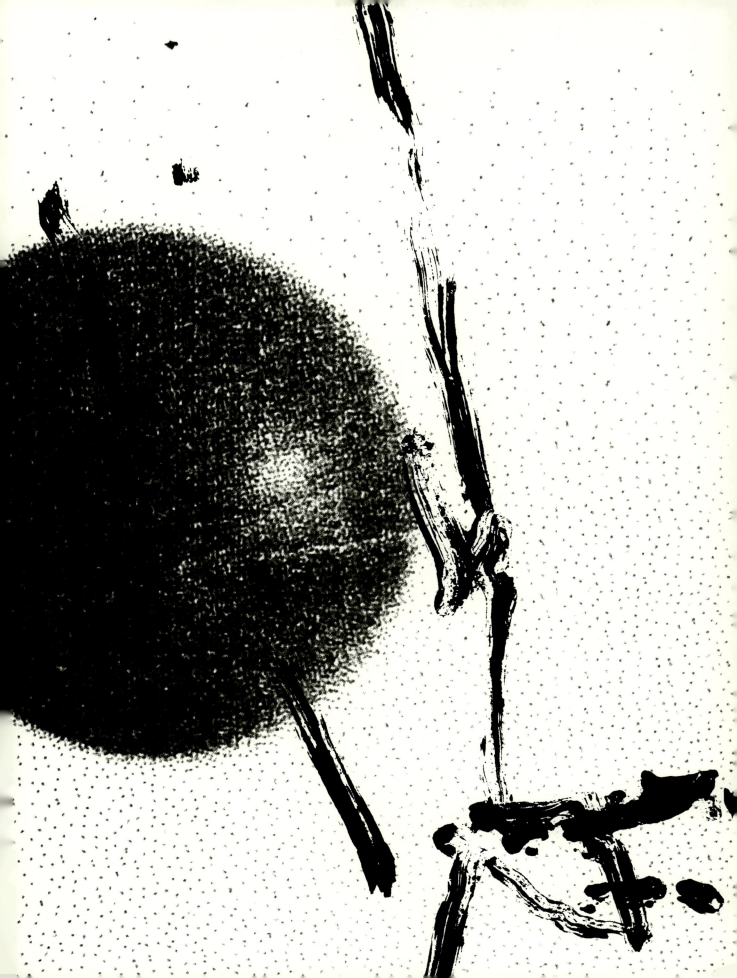

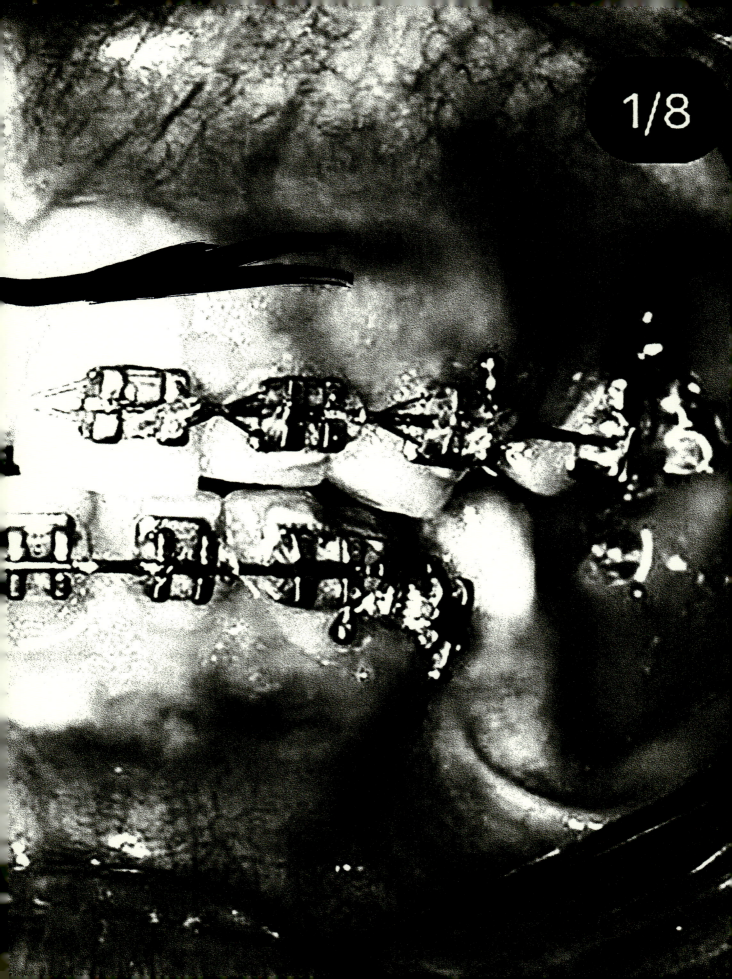

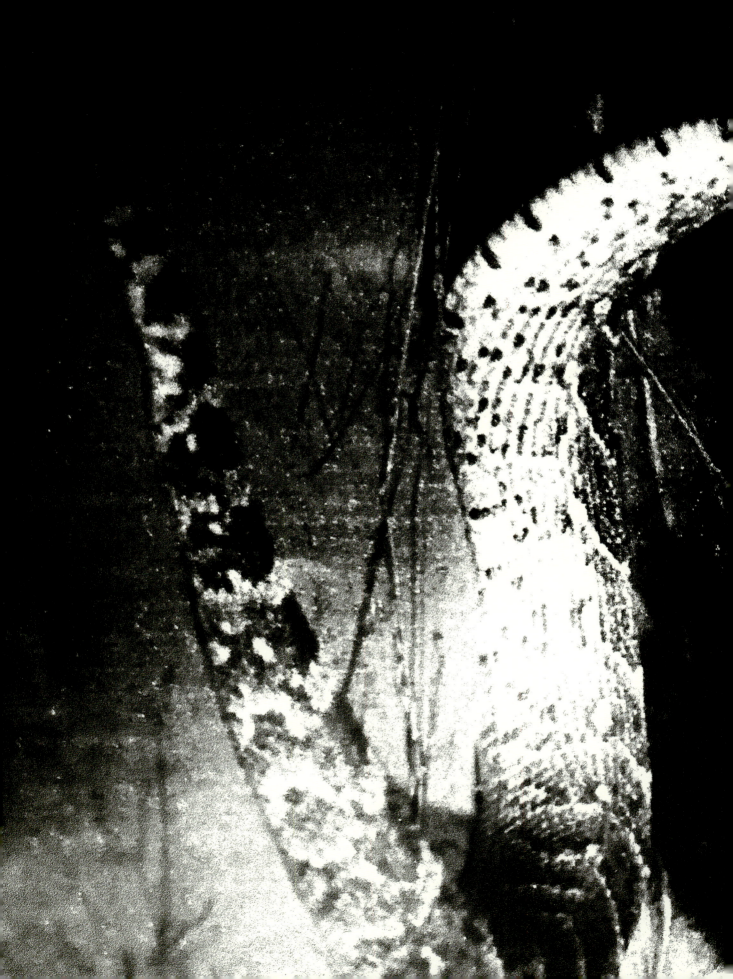

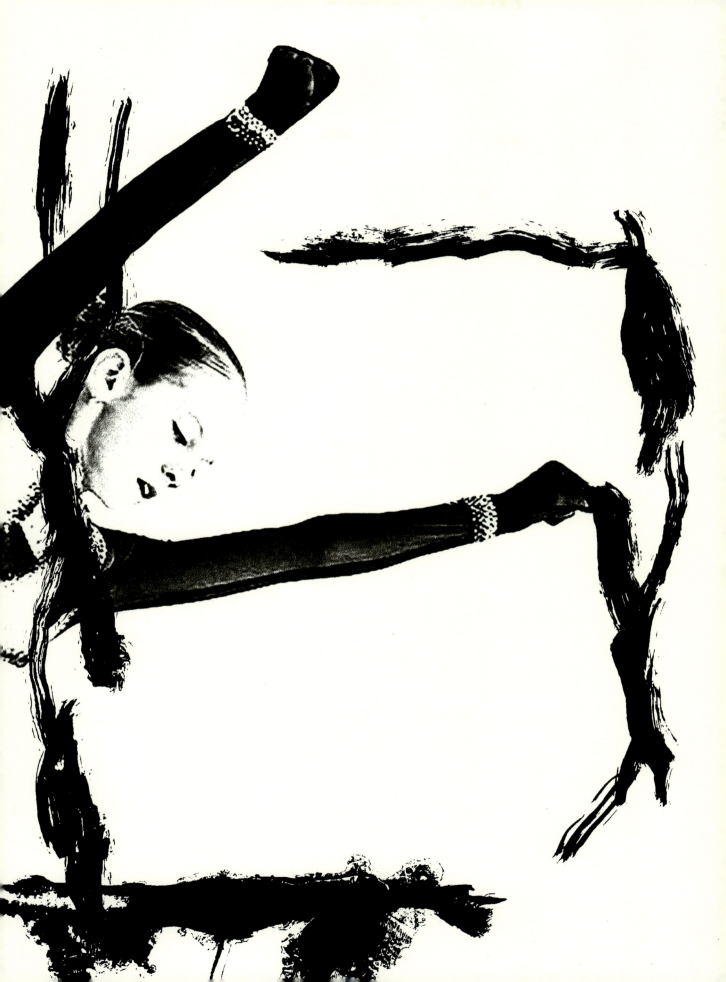

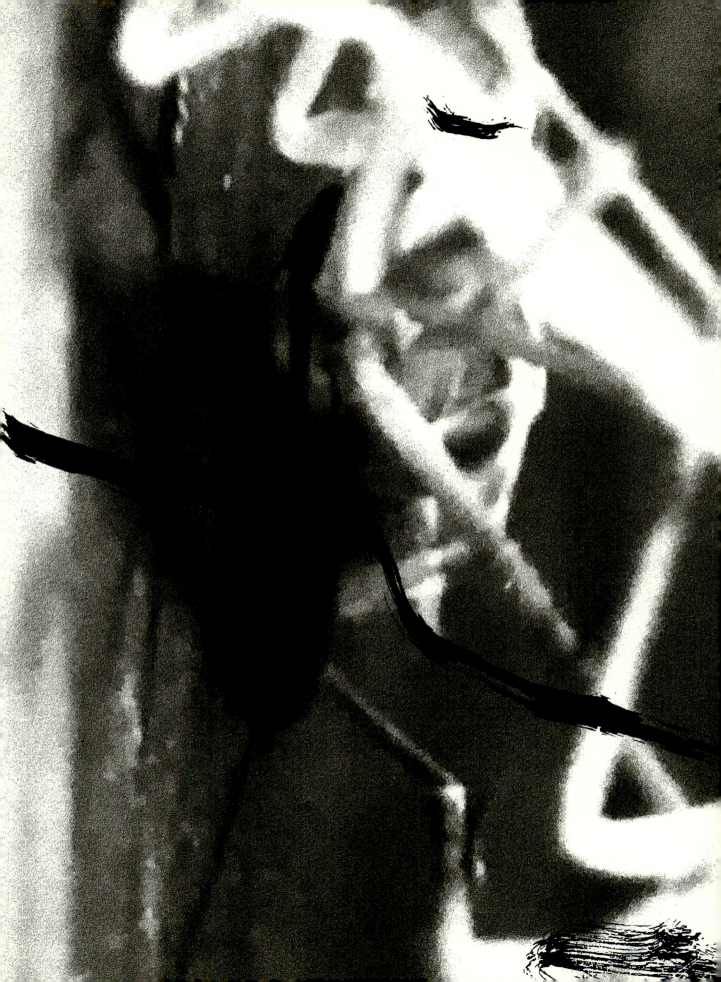

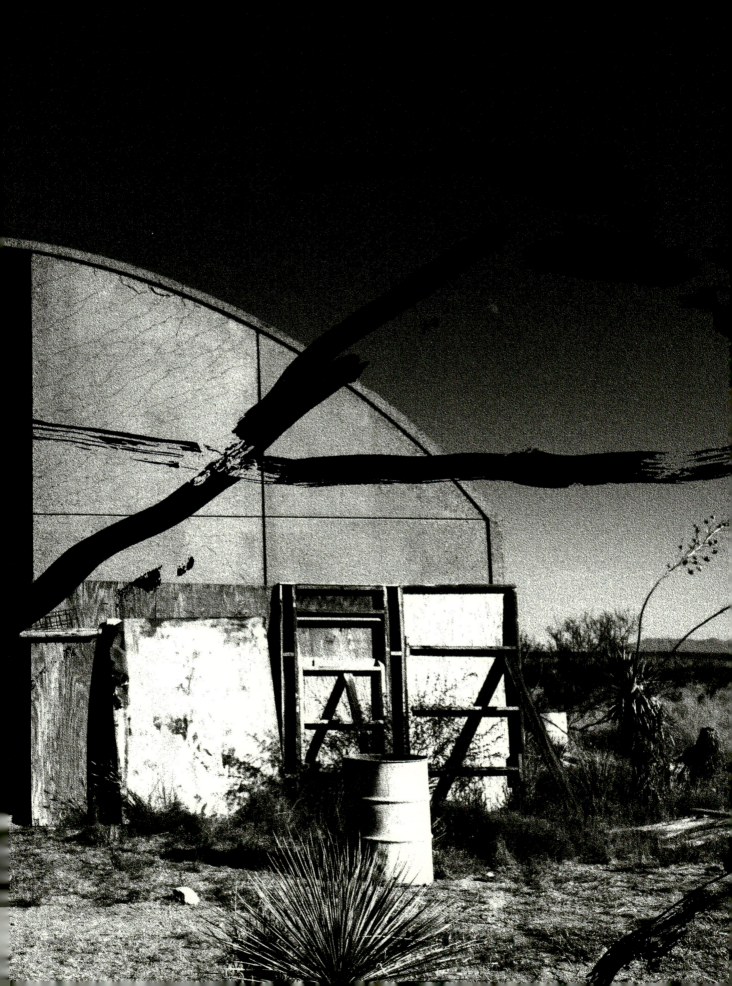

65

Being BRÜT: Rosy Keyser's Cantilever Paintings

by Max Rosenberg

THE NEO BRÜT

What would it mean for art to be *brüt* now? Jean Dubuffet first popularized the term "Art Brüt" (raw, or crude, art) in reference to the art of children and the mentally ill, which he gathered and exhibited in Paris after World War II. Informed by the Nazi occupation of France, Dubuffet saw that which was *brüt* as free, unencumbered, and true, an "artistic enterprise," he wrote, that is "completely pure, basic; totally guided in all its phases solely by the creator's own impulses."[1] If the end result of centuries of Western culture and Enlightenment rationality was Nazis occupying the Louvre, then that which was *brüt* could perhaps offer a true and unmediated historical, cultural, and individual mode of expression that could counter barbarism. So in his own art, Dubuffet adopted the materials and visual forms that fell outside the traditional structures of the fine arts. He sought to elevate the *brüt*, to "rehabilitate mud."[2]

Rosy Keyser has embraced the term "Neo Art Brüt" in describing her practice, and her work, on a basic level, lends itself to the term. Keyser's choice of materials would indeed be at home in Dubuffet's own work. Sawdust, pebbles, ripped and threaded canvas, plastic, and corrugated-steel cladding are just some of the discarded and overlooked matter that appear throughout her art. Yet after nearly a century of artists finding a model of artistic truth in the art of the supposedly uncultured and unrefined, and culling their materials from the domains of the everyday and the refuse heap—not to mention museums and collectors eagerly welcoming every new manifestation of material abjection—it is clear that Dubuffet's mud has long since been rehabilitated. The charge of base and mundane materials and the problematic emulation of the socially marginalized are limited foundations for Art Brüt today, but rather than restate the terms of Art Brüt, Keyser seeks to evolve the concept and spirit that define it.

Having been incorporated into the mainstream discourses of art, the criteria through which crudeness or baseness operate have necessarily shifted, and this is where Keyser has found a model for rehabilitating the concept of *brüt*. While her materials and even the appearance of her work rhyme with Dubuffet's, her art achieves its directness in the way her paintings work between categories and sedimentary histories, engaging the art historical and social associations of her materials and formats so as to create experiences between artwork and viewer that contain a quantum of the directness that *brüt* is meant to signify. Her cantilevered aluminum paintings, a project she began in 2017 during her residency at the Chinati Foundation, in Marfa, Texas, operate at this level of directness. Rendered in reflective aluminum

paint and angled out from the wall, these paintings are more aptly described as encounters, and their forms and appearances are not so much a registration of the choices or processes of an all-controlling author than the material coming into being of de-centered, non-anthropocentric entities.

BEYOND THE SHINY SURFACE

Aluminum is a beacon of surface in the modern world. Unadorned, it presents an untarnished, brilliant veneer of exteriority. As sheets, it is a highly reflective metal—easily manipulable and mundane—that typically encases foods or that lines cookware, or buildings, or spaceships. Perhaps most emblematic of aluminum's superficiality are cans, which operate as an exterior that generates an interior. The surface of a soda can—all corporate branding and iconography, nutritional facts, and unintelligible ingredients— epitomizes pop anti-essentialism. The contents within an aluminum can are defined by the can. It is an inside overburdened by an outside, an emblem of the fiction of interiors and exteriors, essences and appearances.

In art, too, aluminum functions to emphatically declare surface and resist optical penetration to interiors. In the early 1960s, Frank Stella chose aluminum radiator paint for his first series of shaped canvases. Speaking in the 1970s, he commented on his choice: "I was interested in this metallic paint, particularly aluminum paint—something that would seize the surface," he declared. "It would also be fairly repellent. I like the idea of thinking about flatness and depth, that these would be very hard paintings to penetrate. All the action would be on the surface. The idea was to keep the viewer from reading a painting."[3]

A decade before Stella, Jackson Pollock poured and splattered aluminum paint on his canvases, a more unrestrained use of the paint that nevertheless served a similar purpose. In writing about Pollock, Clement Greenberg highlighted and embraced the artist's use of aluminum paint as an extension of a modernist teleology: "By means of his interlaced trickles and spatters," wrote Greenberg, "Pollock created an oscillation between an emphatic surface—further specified by highlights of aluminum paint—and an illusion of indeterminate but somehow definitely shallow depth that reminds me of what Picasso and Braque arrived at thirty-odd years before, with the facet-planes of their Analytical Cubism."[4] The tension between shallow depth and surface that Picasso and Braque accomplished through form, Pollock achieved through the inherent properties of his painterly materials. In Pollock, and especially Stella, aluminum paint served as an efficient, economical means by which to assert the declarative fact of surface, and

artists today, like Rudolf Stingel and Jacqueline Humphries, continue to find distinct means by which to explore metallic, reflective paints as signifiers of surface

Keyser began using aluminum paint in her art roughly fifteen years ago. She is drawn to it as a ground that operates, as she sees it, like the burnt umber or sienna backgrounds in Flemish and Dutch Golden Age painting. Though highly distinct canvas to canvas, the rich, dark grounds of those paintings served as a universal format for a figure or scene to be presented. By using aluminum paint, Keyser pulls the background into the foreground, merging figure and ground, or, more aptly, disregarding figure and ground as meaningful distinctions. The surface of her works are shimmering facades that lure the eye in their brilliance and optical decadence, evoking baroque excess but also rupture, wounds, and burns. Keyser treats paint as materially volatile, the same substance appearing to express itself in a variety of ways. At times, paint lies in smooth stretches of visually ambiguous depth, and at others it appears raised and scarred, or bunched in rivulets and fissures of reptilian texture. In these works, metal's association with impassivity, technology, power, and masculinity are so thoroughly blended with the organic, the fluid, the haphazard, and the entropic as to make the distinctions insufficient.

Rather than a shortcut or tool for expediently declaring surface as surface, Keyser explores the field of material and visual potential contained in aluminum paint, engaging the surface of her canvases as an ongoing process of the work's realization of itself, not as a manifestation of her own ego. Material is less applied than offered as matter and energy for this emergence. Though Keyser determines where sawdust lies, where a tuft of horse hair protrudes, or where paint is applied on the developing surface, the resulting crenulations that arise when the paint hardens are not a registration of action or premeditation, they are part of an autogenetic becoming: expression that is not subsumed by intention. This is matter luxuriating in itself rather than being an inert conduit of the artist or a passive index of other forces: matter that exists unaware of the hierarchies that order, place, define, and submit the things of this world to human will.

Dubuffet's conceptualization of Art Brüt is often contradictory, yet latent within his thought—and seemingly in spite of his proclaimed desire to rehabilitate mud—are allusions to such a principle of unencumbered being, of matter existing without submitting. "One of the principal characteristics of Western culture," he declared in a primitivizing yet insightful lecture to the

Arts Club of Chicago in 1951, "is the belief that . . . man cannot be identified or compared in the least with elements such as wind, trees, rivers."[5] Dubuffet saw this as a limitation. He sought an art that existed beyond such anthropocentric limitations. Keyser's surfaces gesture toward these kinds of identifications; the experience of the works is personal, yet they reflect their own light.

Stella's use of aluminum paint epitomizes a certain efficiency and utility of the material, even while other elements—like the titles he chose—complicate simple readings or experiences of his work. Keyser repurposes the material as something more potent, facilitating its latent expressivity against a reductive logic.

NOT A WINDOW, NOT A FLATBED

For all the variety, ingenuity, manipulation, and variation artists exhibit in painting today, the relational frameworks under which paintings are produced and perceived continue to be informed by the metaphorics of the window (the vertical register) and the flatbed (the horizontal register).

The idea that a painting functions as a window originated in the fifteenth century in the writings of Leon Battista Alberti. In outlining the ideal method for creating a painting, Alberti referred to the rectangular picture plane as "an open window through which *historia* is observed,"[6] a metaphor that oriented how the artist and the viewer relate to the painted surface as a cut in the field of vision through which *historia* (history, story, or narrative) is viewed. The image that virtually recedes behind the surface of the canvas is inherently premised on the canvas's vertical orientation: the work is structured so as to accommodate the viewer's upright posture.

In 1968, the art historian Leo Steinberg gave a lecture at the Museum of Modern Art, New York, that famously identified a new orientation in contemporary art, that of the flatbed picture plane. Later published as an essay, "Reflections on the State of Criticism," in *Artforum* in 1972, the text is not so much a critique of Alberti's architectural metaphor but of the formalist program of Clement Greenberg. In it, Steinberg acknowledges how certain artists have embraced horizontality in the format of their artwork and in their use of materials, seeing in this reorientation a completely new set of criteria by which to evaluate and experience painting.

Writing primarily on the art of Robert Rauschenberg, but also Dubuffet, Steinberg states that these artists' work "no longer simulate vertical fields but

opaque flatbed horizontals. They no more depend on a head-to-toe correspondence with human posture than a newspaper does. The flatbed picture plane makes its symbolic allusion to hard surfaces such as tabletops, studio floors, charts, bulletin boards—any receptor surface on which objects are scattered, on which data is entered, on which information may be received, printed, impressed—whether coherently or in confusion." Further articulating his point, Steinberg makes a remarkable claim: "I tend to regard the tilt of the picture plane from vertical to horizontal as expressive of the most radical shift in the subject matter of art, the shift from nature to culture."[7]

Nature and culture correspond to the orientation of the painting to the observer. Traditional painting's vertical orientation maintains a "natural" relationship to vision: surface as window. Culture, by implication, is the shift to the horizontal interface; to the materiality of the textual, the informational, and the discursive; to images and text as surfaces; and to surface as surface. Though Steinberg clarifies that a flatbed picture can be hung on the wall, like Rauschenberg's *Bed* (1955), it retains the relationality of the horizontal, the cultural.[8]

Pitched at distinct angles and orientations, Keyser's paintings upset these dichotomous logics through their mode of address. Primarily positioned such that they appear to lean back against the wall, the paintings quite literally exist between the vertical and horizontal. The metaphorics of the window are further undermined by the reflective gleam of the opaque aluminum paint: there is no optical probing beyond the surface. At the same time, the relation of dulled patches of aluminum-paint-covered sawdust or other material encrustations to areas where the paint has been spread evenly create a series of concentrated textural and visual relationships that are without a guiding order, suggesting mysterious, opaque depths or indeterminate forms of growth. The paintings are indeed not natural in the way vertical orientations imply. If anything, they reverse the polarity of Jackson Pollock's well-known declaration, uttered in response to a probing question from Hans Hofmann, that his art was not derived from nature, but that he—Pollock—was "nature." Keyser does not claim to be nature; rather, her paintings have their own nature.

Though the works refute the virtual image or optical depths of the vertical register, they also do not conform to the conditions of the horizontal. The cacophony of stuff—text, image, information—that constitutes the cultural would slide off the canvas or be absorbed into its surface as part of the entity and being of the painting. Not a window nor a desk, Keyser's cantilever

paintings are something like the anamorphic skull in Holbein's *The Ambassadors* (1533), a startling memento mori that is literally askew. Even while the scale of the works and the visual charge of the reflective paint give the canvases an assertive, self-contained presence, the angle of many of them, as they lean back against the wall, is also deeply personal. There is a receptivity to the posture of the support that is intimate, enhancing their directness. By comparison, a single work that Keyser leans forward, with the bottom rather than the top directed toward the wall, is decidedly more assertive, near confrontational.

While there are other variations to how she positions the paintings, most are tilted back and their diagonal format calls to mind how a reader holds a book, or, even more demonstrably, how a user holds a smartphone or tablet. Even while techno-consumerist networks seem to colonize the human body and mind, the relationship the individual has with these devices, or their analog predecessors, represent a clear way in which humans recognize themselves to be deterritorialized beings, intermixed with rather than dominating over a vast material universe. Neither purely window—though they are that—nor horizontal desk—though they create a surface of images and texts—these technologies are intimately grasped as part of the structure of their interfaces. Keyser's panels are too large to be casually held, yet like the constantly shifting, transforming visuals on the screen, her work suggests the polymorphic nature of the image, their metallic surfaces appearing like a steampunk Rorschach test in which glimmers of form appear and disappear in tandem with the mind's projections and associations—something there and not there, dependent and independent.

LIKE US AND NOT LIKE US
Even while they evoke a certain kind of futurism, the surfaces of Keyser's paintings are also primal, appearing like an alien primordial soup. At the same time, Keyser's cantilevers thrust the paintings into history, and they read as both archaic and modern. Primarily comprised of industrial pipes, these structural supports serve as a tool for the paintings to present themselves—as though the works are determining their existence in the world—making them contingent yet also enabling them to assert a degree of independence from the wall and the floor.

So while the paintings resist the anthropocentric category of the vertical, they are also not the purely contingent surfaces of the horizontal. Their crudeness or directness—their *brüt*ishness—is that they are themselves. They

neither hide their secrets—the versos are there to be seen, stretcher bars and all—nor are they simply open, fully transparent, and accessible either. They are as sovereign—as self-determining, as unimpeachable—as anything or anyone, which is to say, not especially sovereign at all. They are like us and not like us.

Dr. Max Rosenberg is an art historian and critic living in Brooklyn, New York.

73

NOTES

1. Jean Dubuffet, "Crude Art Preferred to Cultural Art," in *Art in Theory 1900–2000: An Anthology of Changing Ideas*, ed. Charles Harrison and Paul Wood (Malden, MA: Blackwell Publishing, 2003), p. 607.

2. This was the title under which Dubuffet's text "L'auteur répond à quelques objections," first published in a catalogue for an exhibition at Galerie René, Paris, in 1946, was republished. See Dubuffet, "Réhabilitation de la boue," *Juin* (May 17, 1946).

3. Frank Stella in *Painters Painting*, directed by Emile de Antonio (1972), 35 mm film.

4. Clement Greenberg, "'American-Type' Painting," in *Art and Culture: Critical Essays* (Boston: Beacon Press, 1961), p. 218.

5. Jean Dubuffet, "Anticultural Positions," reproduced in *Dubuffet and the Anticulture* (New York: R.L. Feigen & Co., 1969), n.p.

6. Leon Battista Alberti, *On Painting*, ed. Rocco Sinisgalli (New York: Cambridge University Press, 2011), p. 39.

7. Leo Steinberg, "Other Criteria," in Branden Joseph, ed. *Robert Rauschenberg* (Cambridge, MA: MIT Press, 2003), p. 28.

8. Stemming in part from Steinberg's analysis, Rosalind Krauss and Yve-Alain Bois's conceptual formulation of the horizontal within Georges Bataille's notion of the *informe* (formlessness) adds a wrinkle to the nature-culture dichotomy that Steinberg establishes, but their discursive reformulation of the horizontal maintains the dichotomy between the vertical and horizontal that forms the basis of Steinberg's critique, and as such operates around a similar binary logic. See Krauss and Bois, *Formless: A User's Guide* (New York: Zone Books, 1998).

Her Dark *M*aterial*s*: *Th*e Unsettling World *of* Rosy Keyse*r*
b*y* George *P*end*l*e

Into this wilde Abyss, The Womb of nature and perhaps her Grave
—*Paradise Lost* (1667)

I was curious to see what was going on at this perverted passion
pit you're running here. This orgy bin. Whatever you call this
drug-crazed nipple ranch.
—*Club Paradise* (1986)

There's little doubt that if Rosy Keyser had lived in the seventeenth century, she'd have been burned at the stake as a witch. There's just no way she could be allowed to survive, not if she was making images like she's making today. Just look at the materials listed next to her paintings—sawdust, horsehair, coconut, obsidian, sheets of mica, eye of newt, wing of bat. Well, not the last two, but they're not much of a stretch. And yet seamlessly interpolated amongst her dark materials is a more quotidian array of stuff—suspenders, beaded car-seat covers, beer cans, garage doors. As much as Keyser can appear shamanic, she can also seem like the cackling proprietress of a foul rag-and-bone shop.

This mix of materials both high and low appears to have naturally oozed out of a childhood spent in the Maryland countryside, north of Baltimore. Her earliest memory is of a red deer, dead in a green and brown cornfield. As a child, she recalls avoiding copperhead snakes and picking Queen Anne's Lace by the side of the road, making bowls of pioneer food in the woods, and collecting eggs and carrying water buckets up to the barn. It was the barn that provided so many of her artistic substances. "Sawdust is the universal," she says. "You have it in stalls, on barn floors. I spent a lot of time on it and around it. It absorbs a lot of life's shit." Then there was the tar and corrugated iron and old straps and twists of rope, the kind of stuff you could find decaying and molded over in the corner of a farm-yard. Keyser has a feeling for the disheveled, beating heart of inanimate things. "I think my sister and I spent a lot of time looking at dead animals with dried blood all over them," she says. Swept up and affixed to the wall amidst wild slathers of paint, these repurposed items have been ennobled and re-animated. "Your barn floor is my cathedral," she says.

The first artist to mean something to her was the landscape painter Eugene "Bud" Leake, whose studio was in a hayloft nearby. Leake's style was impressionistic in his early days, but by the time Keyser knew him, he was in his eighties and his work had become darker and more abstract, the brushwork looser and the paint thicker, as he concentrated on portraying night scenes and the barely perceptible. "They were channeling something ineffable through the most simple forms that I saw every day in the Maryland landscape." Keyser remembers visiting his barn studio. "That's my first memory of the smell of oil paint," says Keyser. It was this mix of oil and hay, of art and nature, that made the nine-year-old Keyser alter her dreams of becoming a rabbit handler and decide she wanted to become an artist.

She studied at Cornell and the Art Institute of Chicago. A short stay in East

Palo Alto saw her painting murals and muscle cars. She was a cocktail wait-ress in New York for some time, working nights and hauling empty Bazzini peanut cans back home on the bus to use the next day for her brushes and turps. She now splits time between Brooklyn and Medusa, a small hamlet in upstate New York that still provides her with an infusion of the rural.

In the studio, she follows a shifting cathemeral routine, like a coyote, arriv-ing at her studio at either ten in the morning or ten at night. The studio's walls are covered with images of vampires, natural disasters, and odd photographic details from the sports pages of the *New York Times*. She lays out her drawings and materials and then begins to work at great speed. She's slight and swift, often seizing whatever is closest to hand to produce an unexpected effect on her canvas. She usually paints with the canvases on the floor beneath her, wearing a tank top and cut-off corduroys so she can move about unimpeded. "Everything essential to life happens on the horizontal plane," she says, "the birthing, the lovemaking, the dying, the crawling around looking for food, the crawling under a bush to die." At times when she works, it looks like she's performing an autopsy on her canvases, revealing the ribbing and viscera of the painting, or taking part in an archaeological dig as it unearths indeterminate remains and ancient detritus.

She is an inveterate scavenger. A walk in her company sees her gather feath-ers, leaves, sticks, and torn magazines from the sidewalks. But her rela-tionship with her materials is deeply reflective. She describes obsidian—a type of cooled lava—as "like sawdust, in that it has been another form. It's something fluid made into tiny surfaces. And it has this grit that is really sharp and can cut you. You can scatter it; it's ritualistic; it sinks into enamel [paint] or sits on its surface." Humor, so often missing from contemporary abstract art, lies on and around the canvas too. Take her use of suspend-ers, which she uses to play with ideas of contraction and extension, or the titles of her works—*Hobo Detective*, *Terrestrial Escape Hatch*, *The Hell Bitch*—which have a Captain Beefheart–like surrealism to them. For all the process-driven and ritualistic elements of her art, there is a puckish air about it, and about her. She loves Maggie Nelson's writings on aesthetic theory and gender fluidity but also the universally panned Rick Moranis/Robin Williams comedy *Club Paradise* (1986). She is as likely to find inspi-ration in Albrecht Dürer's *Great Piece of Turf* (1503) as she is in Daffy Duck's cartoon short "Duck Amuck" (1953). When she's not stooped over a canvas, she takes breaks by bouncing on a trampoline.

Her first solo show, in 2008, was *Rivers Burn and Run Backward*, a collection of large, shadowy abstractions, often with a streak of light glowing outwards from them like the bioluminescence of foxfire. Critics pointed out that she occupies a zone between sculpture and painting, and it's not hard to see why, with the paintings' encrusted surfaces and thick layers of impasto. She's fascinated by how paintings can be understood as "a scaffold for holding form." But what's just as stimulating is the way her canvases seem to create a sensory threshold on their surface, a liminal space that both draws the viewer in and pushes them away.

To achieve this effect, Keyser uses a multiplicity of techniques. Dye is absorbed into her canvases, while enamel house paint is layered on top of them. Nails stick out like metal toadstools, while sometimes the canvas itself is peeled away to reveal the stretcher beneath, web-like string looped over the open frame like a negligee or cartilaginous skeleton. Her frequent use of corrugated iron turns the surfaces of her work into something akin to a visual roller coaster, rolling out toward the viewer before sinking back in. "Things are in this constant state of moving up and down, and that's the action of a painting . . . even though the paint or the objects on the canvas have found an angle of repose."

In her organization of form and chaos and her use of orphaned and unlikely materials, Keyser's work has been likened to everything from the Action painting of the 1950s to the Neo-Expressionists of the 1970s and '80s. Her personal lexicon of materials even sends reverberations back to the shamanic art of Joseph Beuys. For Keyser, a constant source of inspiration has been the idiosyncratic practice of the Italian artist Carol Rama, whose work veered between sexually explicit watercolors and abstract reliefs incorporating inner tubes and ragged leather. Early on in her artistic career, Keyser termed her work as "Neo Brut," and that reference to art made outside the academic tradition might still be the best term for her. Her work is linked, as if by umbilical cord, to the assemblages of such artists as Thornton Dial and Lonnie Holley.

Nevertheless one of her favorite paintings is Jean-Baptiste-Siméon Chardin's distinctly classical still life *The Ray* (1728). It depicts a kitchen scene in somber browns and grays, but dominating the oysters, fish, and hissing cat is the form of a butchered ray hanging above the table. The ray's eerie face peers out of the canvas, as if it was alive. "It's trying to live in the animate world and be in the inanimate world at the same time," says Keyser.

It's fair to say that ghosts haunt Keyser. When she was young, her family moved to Ireland, and she recalled seeing the spirit of a woman who was said to have hanged herself in the window near her bed. She describes how she wants to be "someone who addresses the shadow as necessary," and while the ghostly geometric presence of Chardin's ray itself can sometimes be found in her paintings, her very technique creates apparitions too.

Keyser's canvases are often frenetically overworked with enamel paint before being pared back, the images covered by a shroud of spray paint until just a tiny contour of the original work is left exposed. "Most of the time things have to go to a far-off place in order to come back and be interesting," she says. "This one sliver shows you that [the painting] took this journey." Looking at one such work, it almost feels like the original painting is being buried alive in the canvas, like a body buried in the garden that is only noticeable by the tilled earth above it. "The ghost of the scrapped is always represented," she says. "D.H. Lawrence talks about Cézanne's paintings as 'landscapes of omission.' I'm taking apart the work in the interest of explaining it, then [I] put it back together using the parts that you, as the artist, feel are the most essential, the most telling. Sometimes the shadows contain the most information."

Experiencing the paintings in person can be infinitely rewarding. There is not so much a geography as a geology that can be found on her canvases. Weird spores cluster in metallic valleys. Encrustations of paint suggest tectonic movements. The micro becomes macro in this splintered landscape. And yet, stepping back, one sees the picture coalesce into something whole and complete, like looking at the world from outer space. Her paintings become biomes of scrap and paint, a glorious ecology of the artist's own consciousness.

In her latest series of paintings, Distal's Musk, exhibited at UMBC's Center for Art, Design and Visual Culture, it might seem like her modus operandi has changed somewhat. These paintings are uniformly silver, suggesting a certain inorganic and aesthetic hauteur quite at odds with Keyser's usual vital splatter. Then there are the cantilevers that thrust these canvases away from the wall. It soon becomes clear, however, that this is more an encapsulation of her past technique than a repudiation of it.

For a start, the silver—actually aluminum paint—has a heavy mineral air to it. When combined with Keyser's sawdust, it gains a weird new quality, as if it is part alien and part terrestrial. The canvases may be less pitted and

furrowed than her previous work, but they still contain multitudes within them. "I was using [the silver] as the burnt umber of yesteryear," says Keyser, "the neutral vibrating form that you can either push or pull from. There are so many other things that I want people to pay attention to that I wanted the uniformity of silver. But it's not actually that uniform because it picks up other colors."

Then there are the cantilevers themselves. These structures push the paintings out to meet us, making them float before our eyes like apparitions, or indeed, Chardin's floating ray. If the surfaces of Keyser's paintings have always pushed and pulled the viewer's eye backward and forward, then these cantilevers abet this in the most dramatic way possible. For Keyser, the cantilever allows the painting to "get independence from the wall and from the viewer," lending it a "choreography of exile." The cantilevers provide a strange feeling of depth, of creating a solid area between you and the canvas that is almost a visual illusion. The cantilevers themselves act as a kind of portal or cave entrance, a mandible jutting out ready to scoop us up and deposit us in the maw of the work, a real-life threshold that we have to pass through. The effect is both destabilizing and embracing, as if the canvas was itself breathing.

Keyser even thought about cantilevering the very walls of the gallery when she showed these works, thus making the whole room unstable, with pictures pushing out and tilting backwards from walls that are themselves pushing in and leaning outward. The result was to make the viewer feel like they are inside an ever-moving space, pressed up against the artworks and then pushed away from them, trapped in the space with them. It would be a haunted house if everything wasn't so palpably alive.

Ghosts, instability, moving walls, living things buried just beneath the surface. Such themes are fitting for the city in which Edgar Allan Poe is interred. Poe mastered the art of burying things in walls or under floorboards where they couldn't help but leak back out and reveal themselves. The black cat screeched from behind the bricks; the ripped-out heart beat loudly from beneath the floorboards. The instability and transformation found in Keyser's work is not quite the gothic horror of Poe, but it is similarly squirreling and alive and quite unable to hide.

George Pendle writes on art, science, and culture for frieze, Cabinet, The Economist, *and* Esquire. *He has written books on occult rocket scientists, forgotten American presidents, and death.*

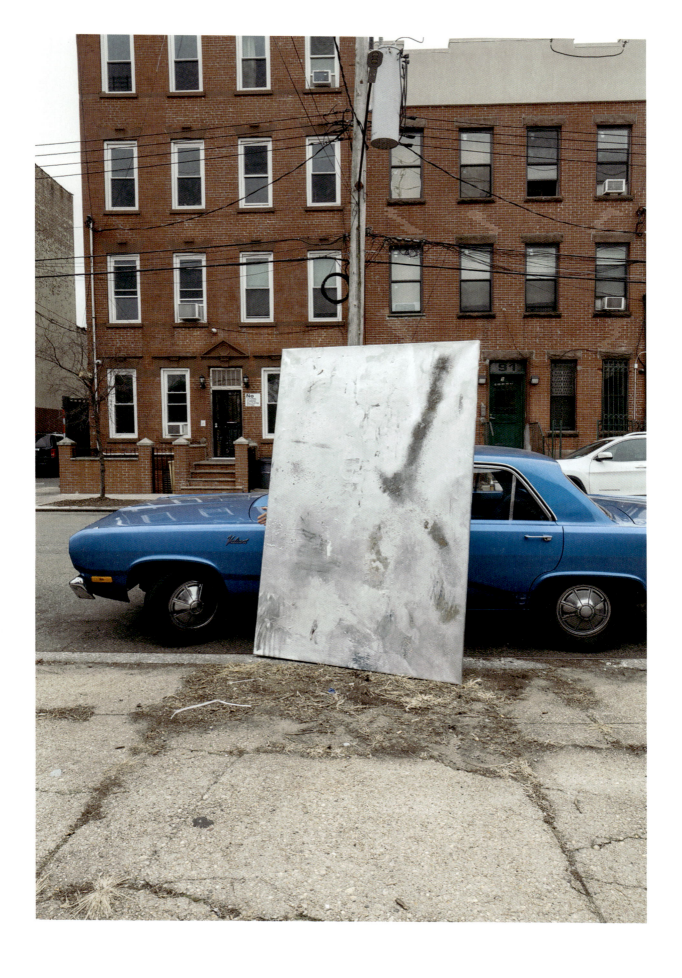

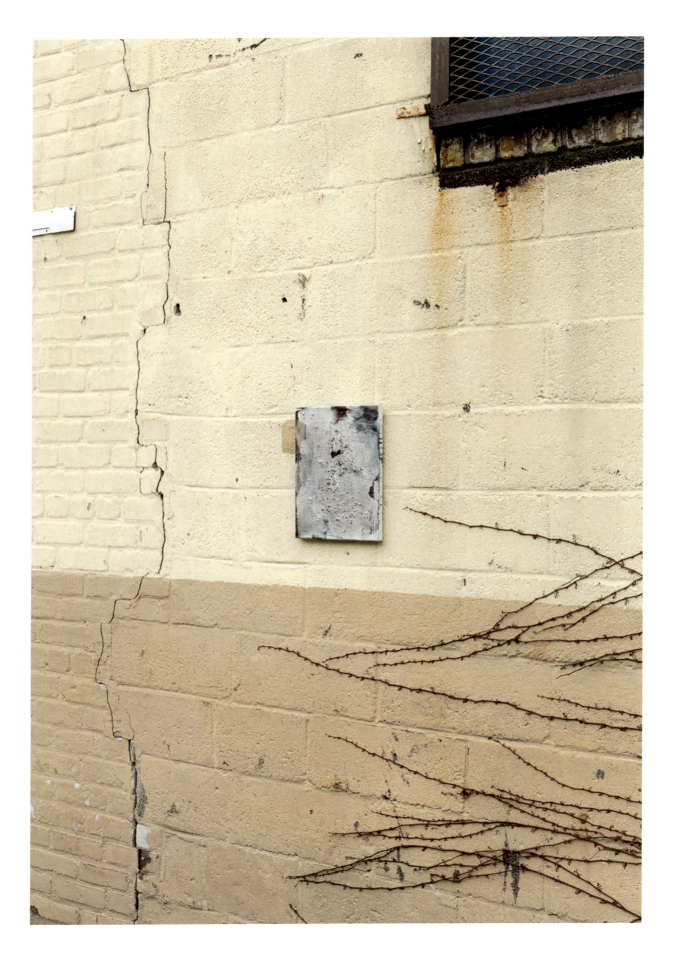

83

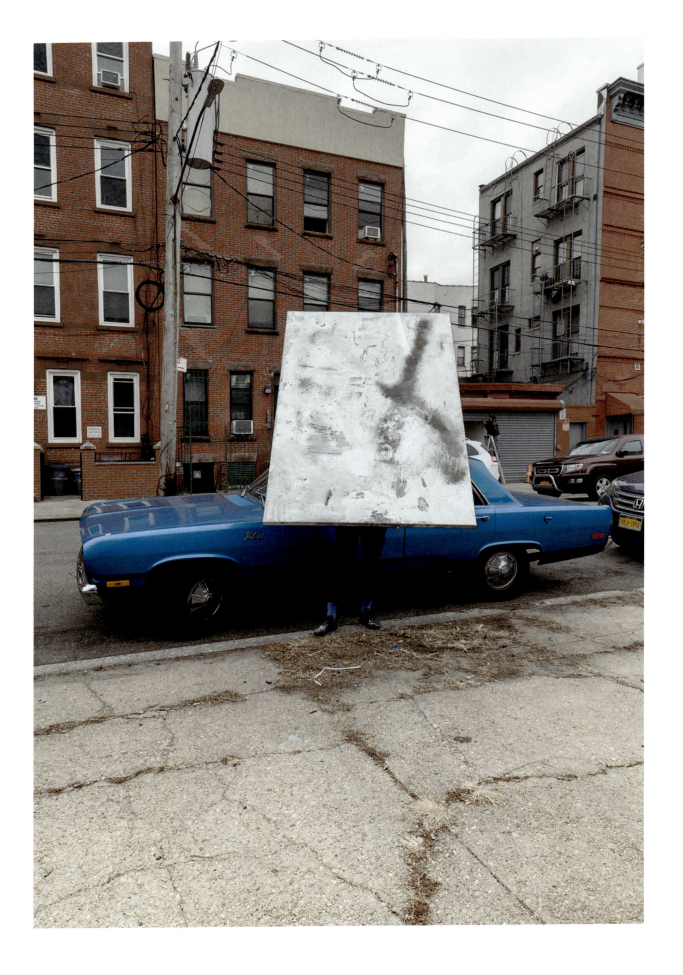

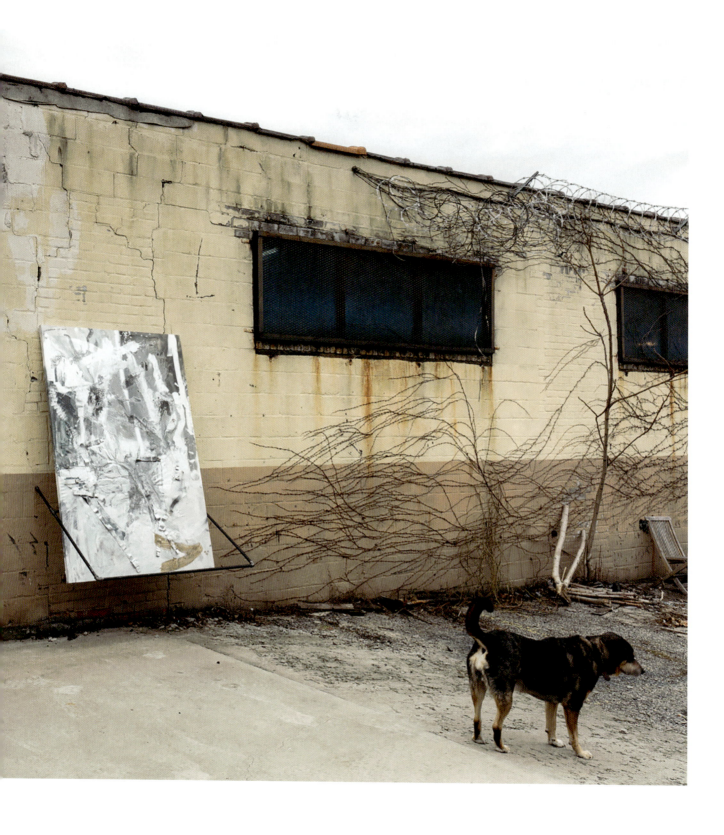

89

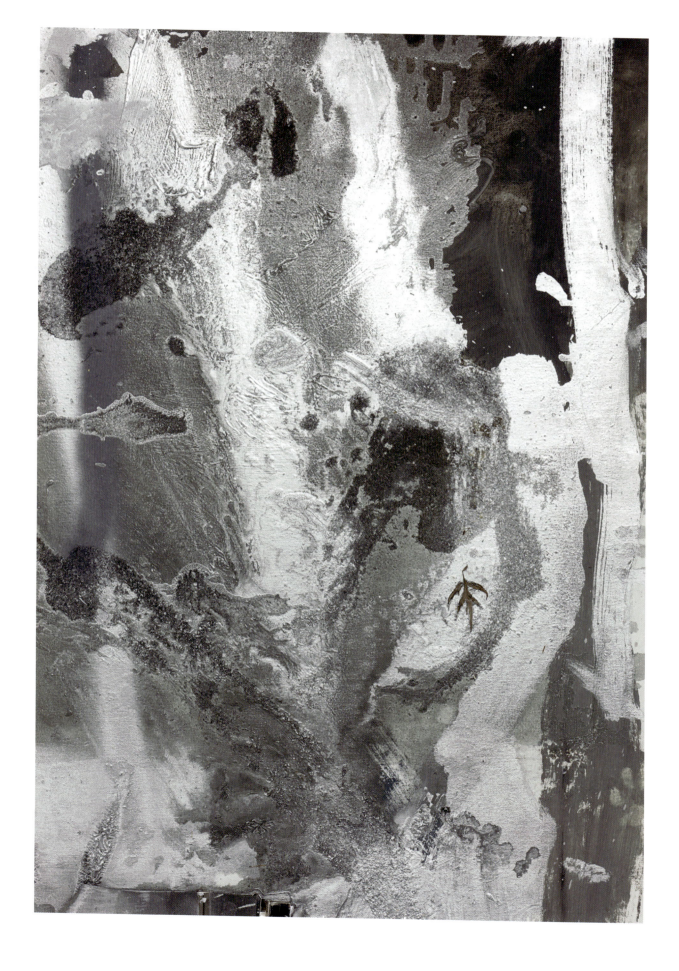

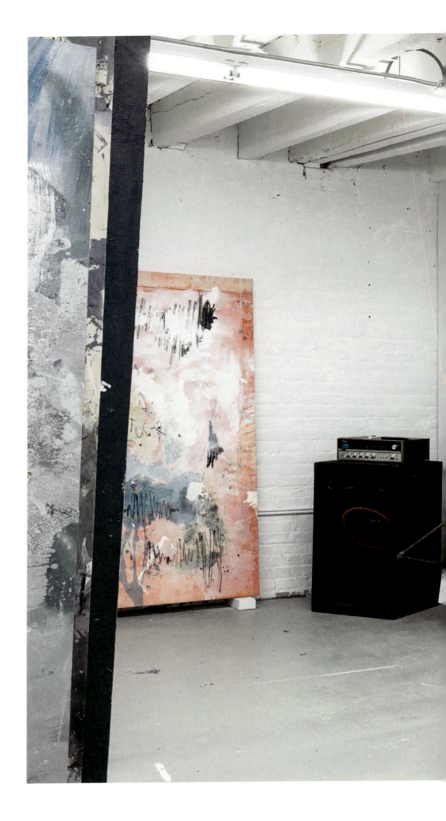

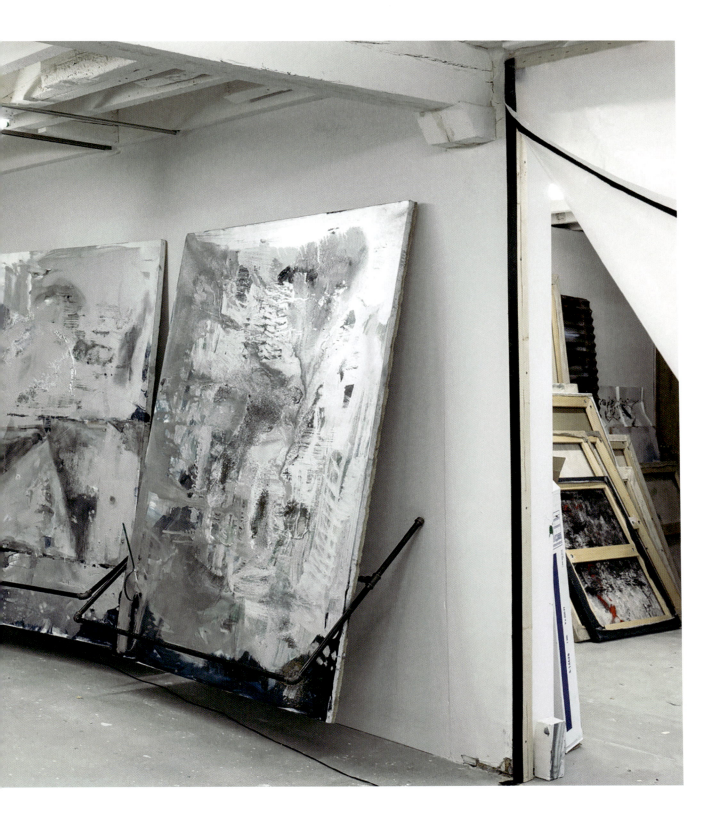

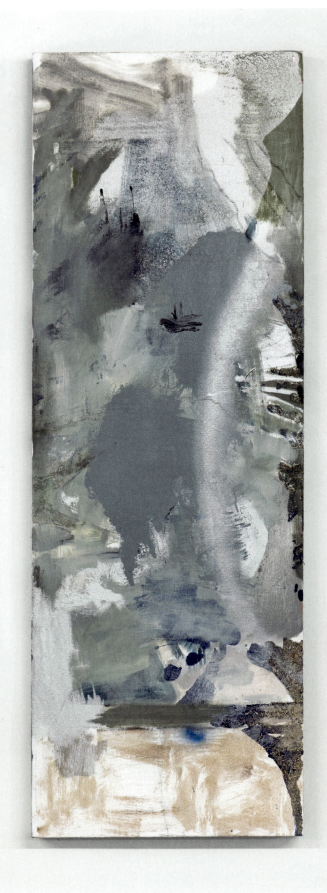

93

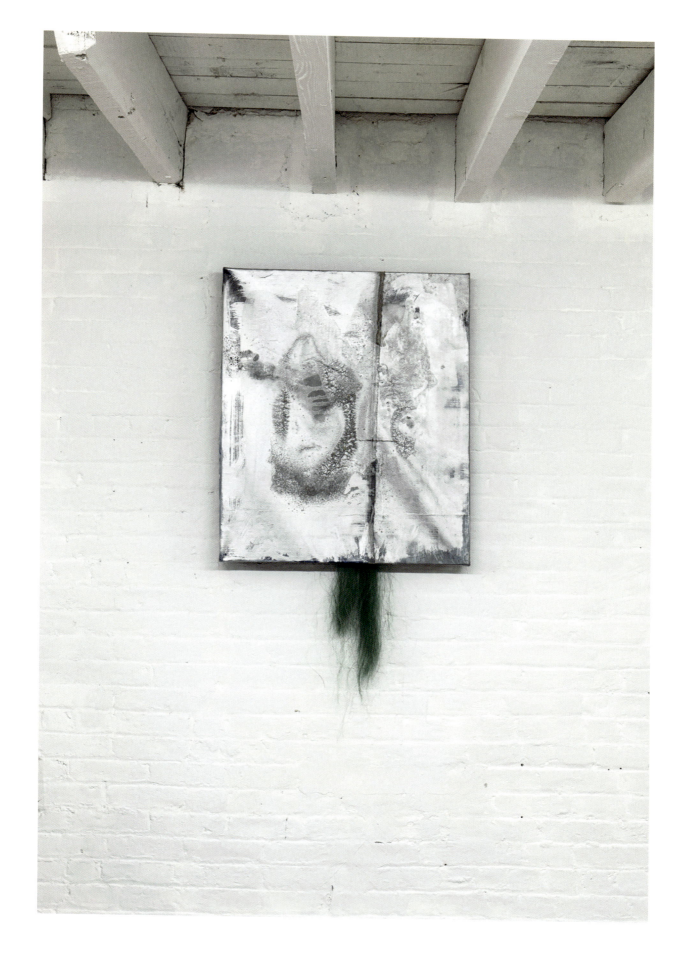

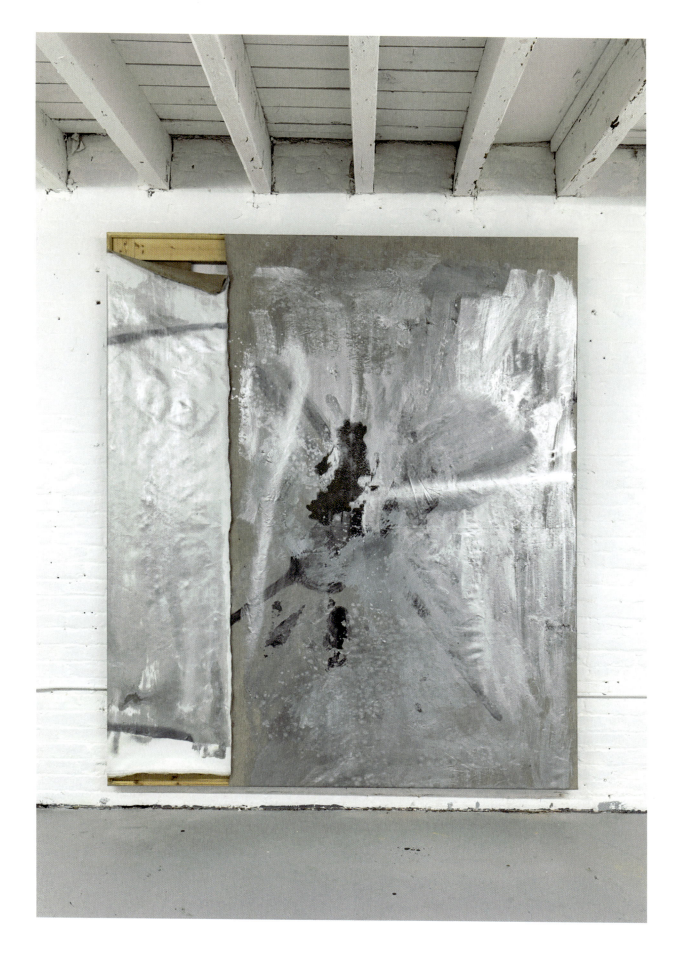

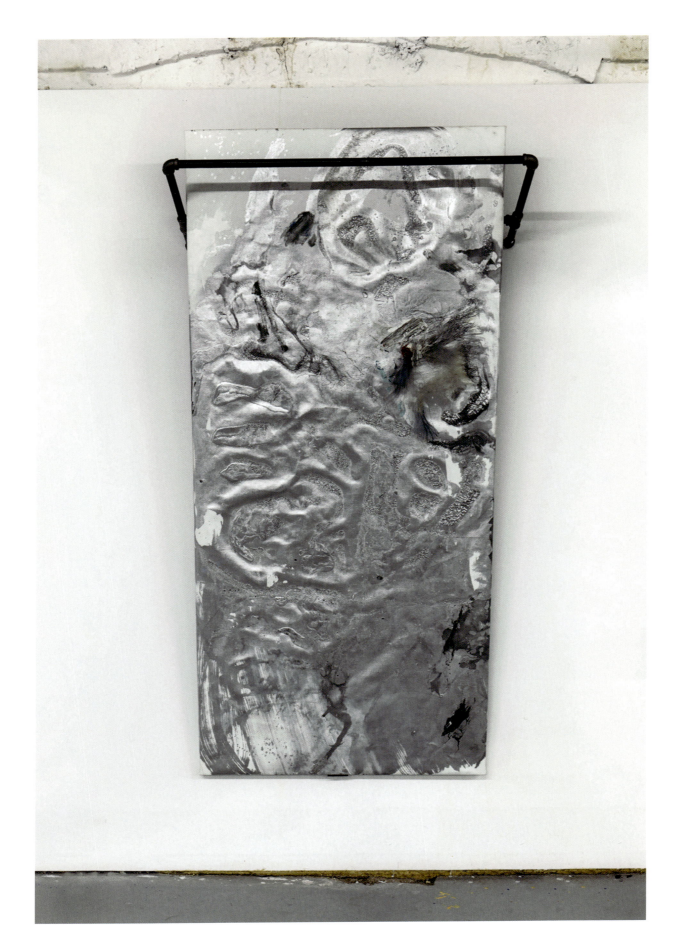

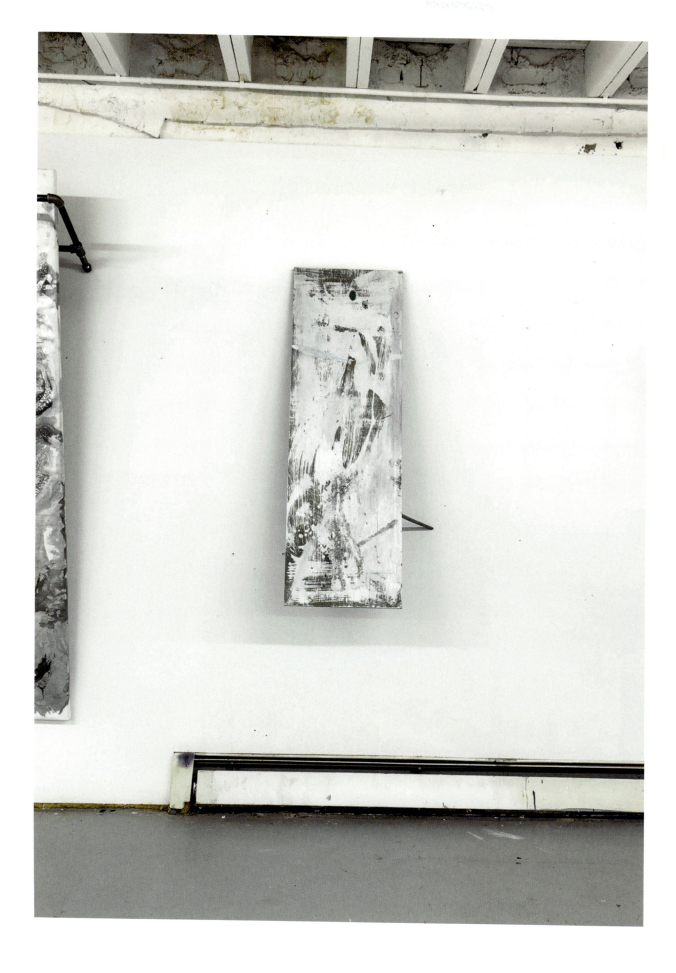

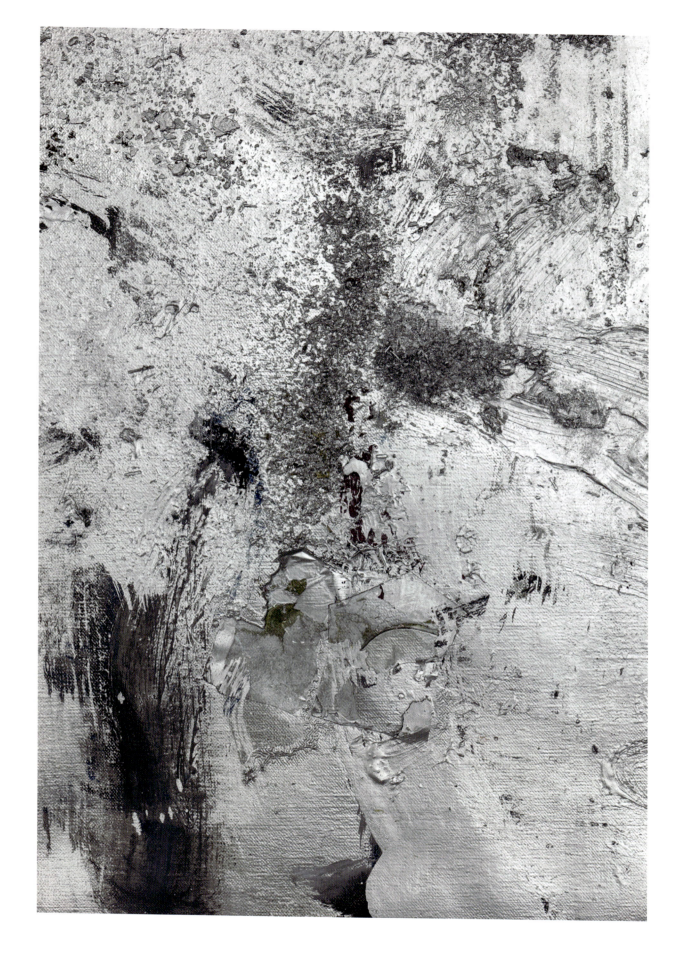

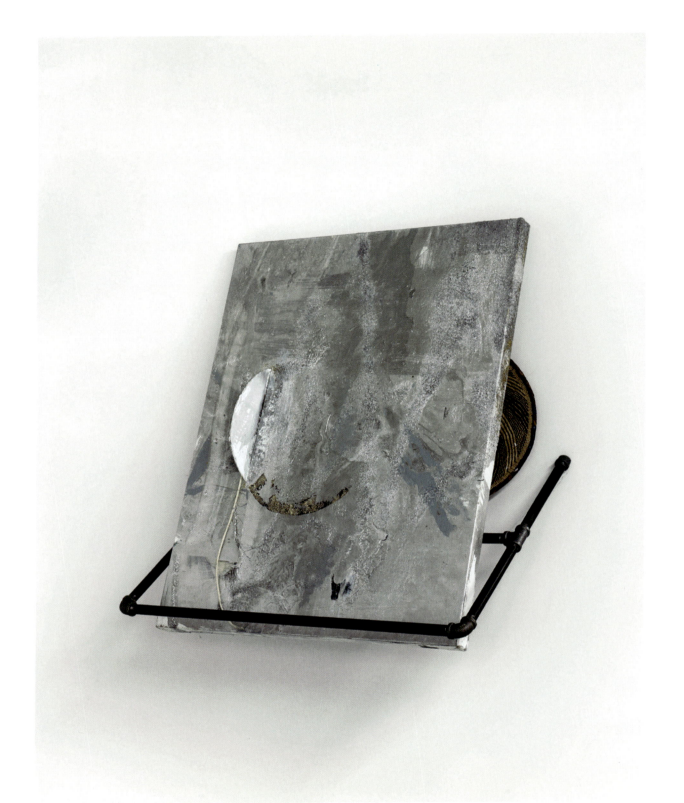

103

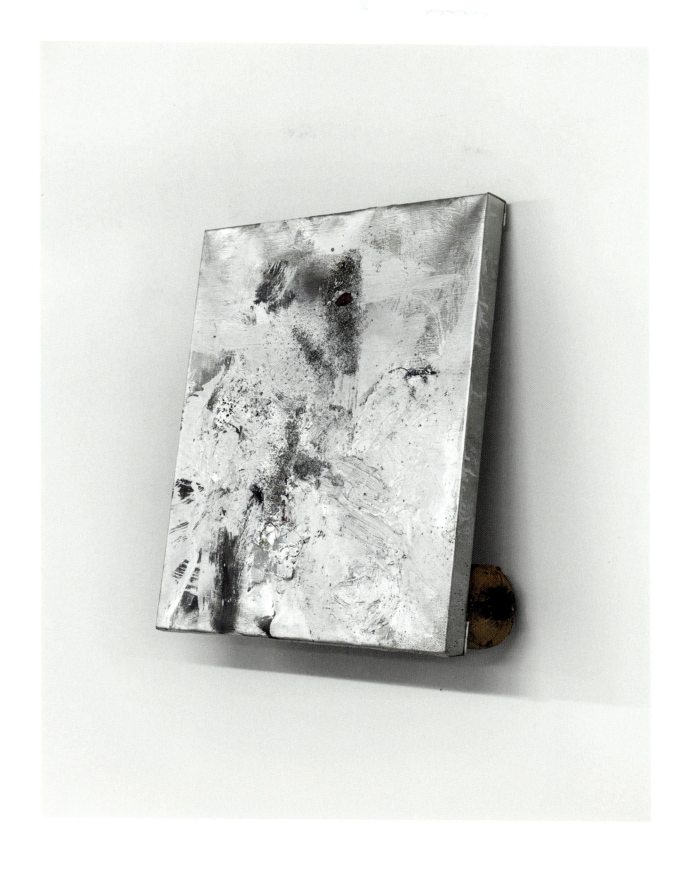

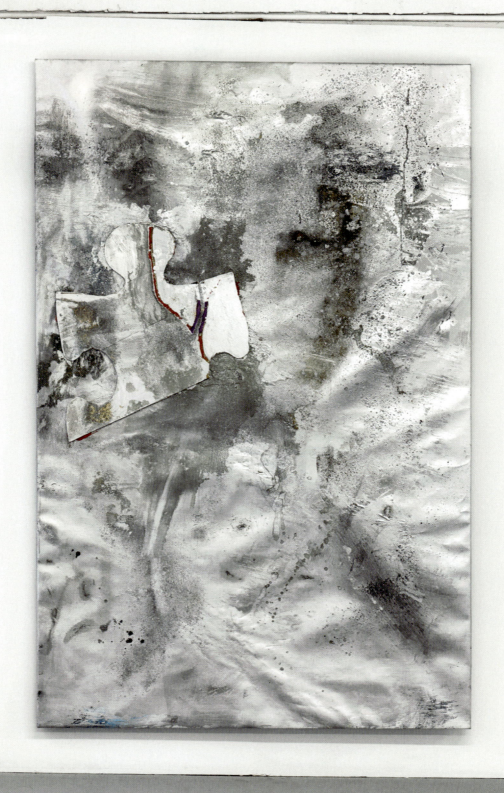

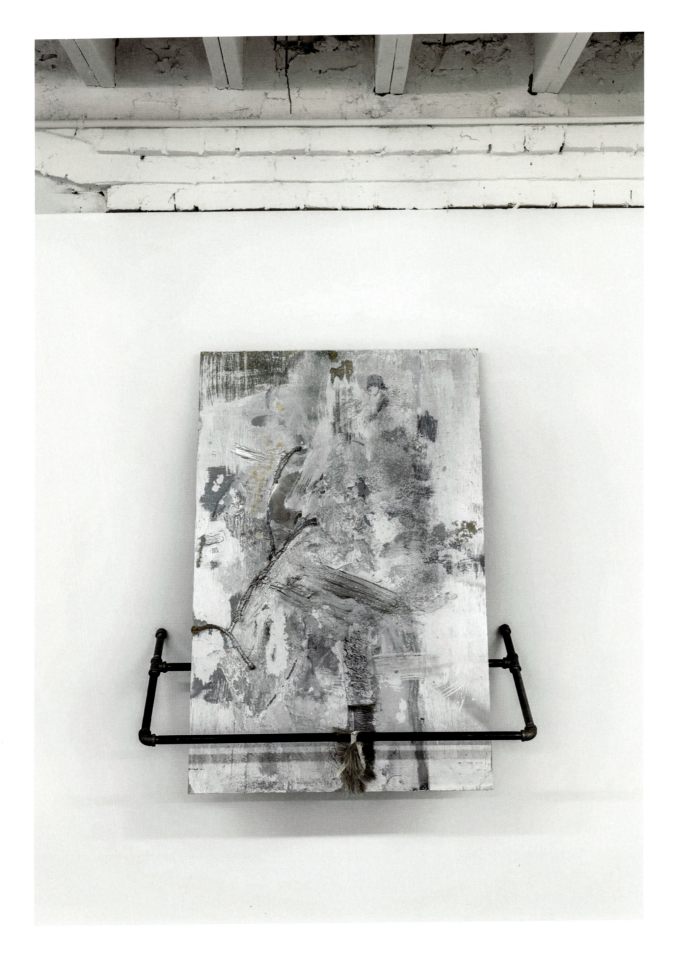

107

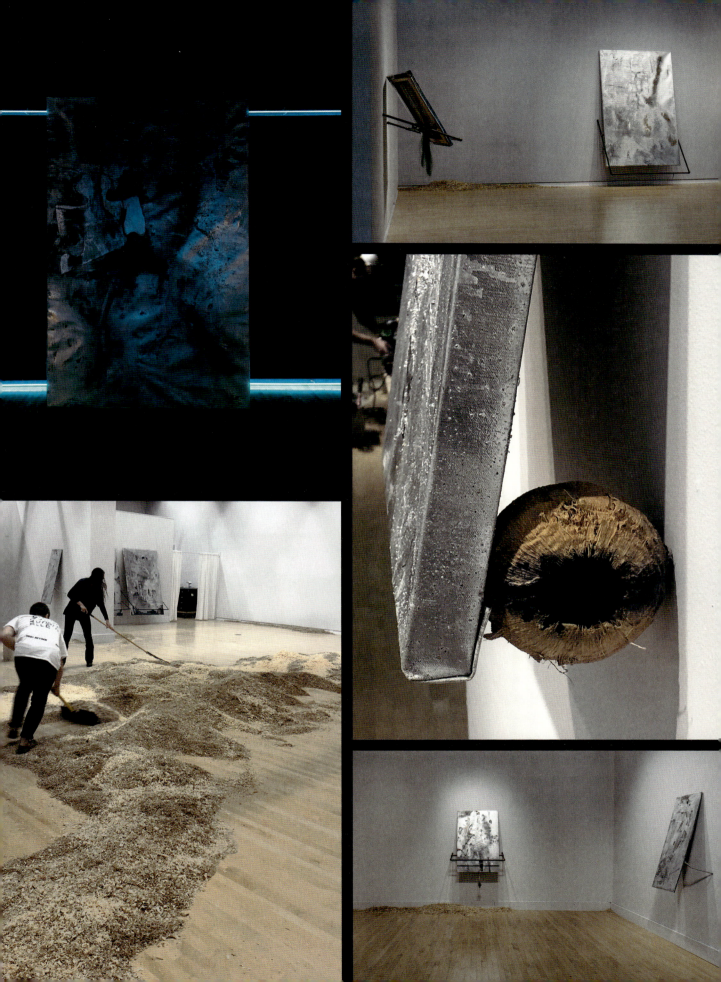

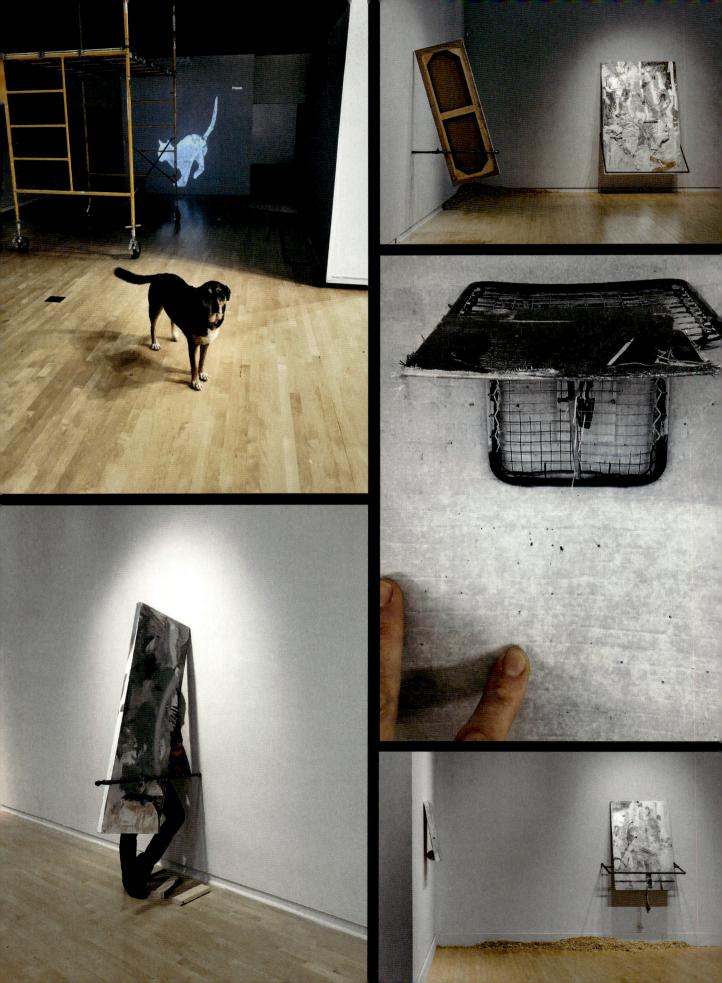

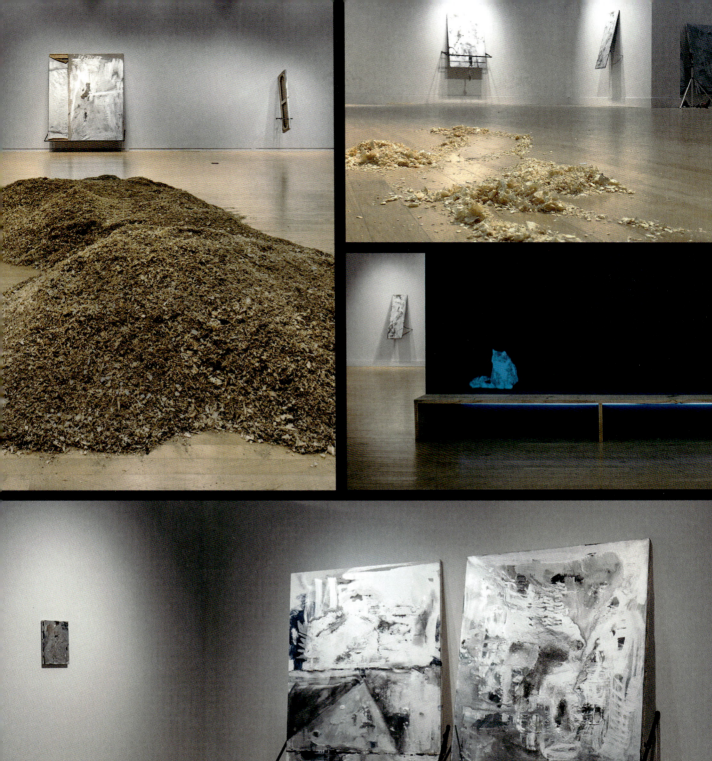

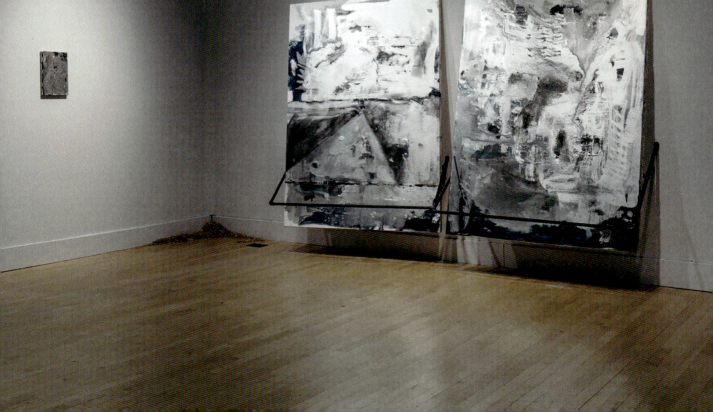

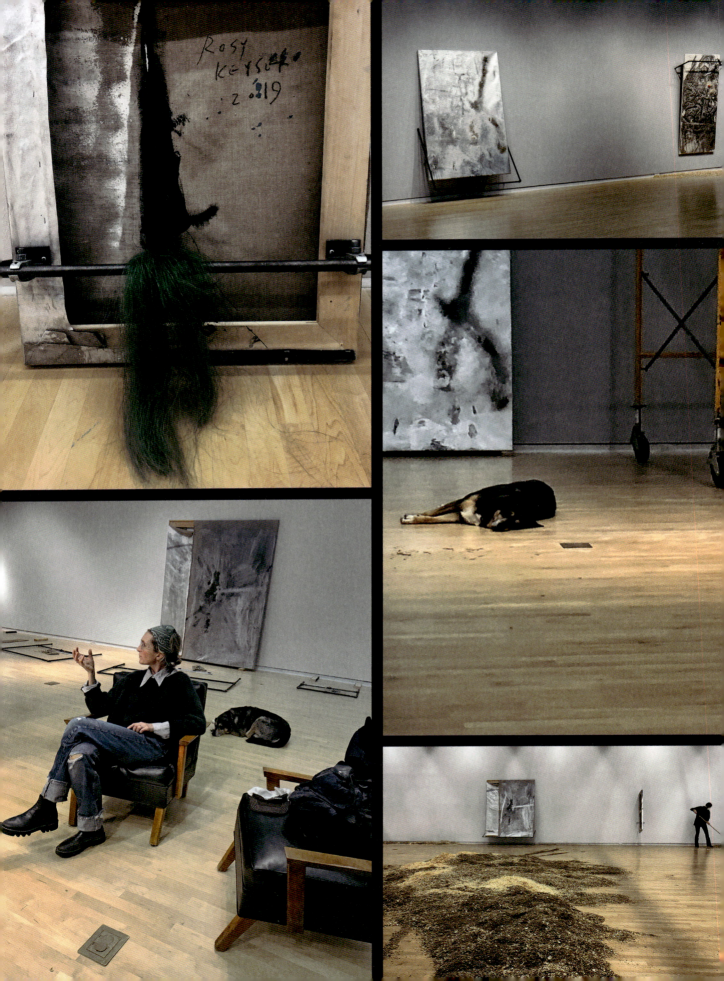

The structure is complete. Fourteen paintings, sawdust, cats, blue neon lights hugging the bottom of one wall, and an abstract audio soundtrack coming from a small theater in the gallery space. Feline and feral, the cats, or rather projections of them, keep their distance while the paintings throughout the gallery become intermittent slivers of light among assorted piles of sawdust. The gallery space is illuminated by the gallery's light track as well as by its florescent work lights. The result is the paintings appear deflated as objects and rather are perceived as windows or conduits to an exterior environment outside the gallery. In various positions, the paintings lift away from the walls. Via a cantilever pipe system used as a support structure, a quality of floating, without gravity, is produced. An atmosphere of shape-shifting parallelograms is evident. The lifting away from the wall also creates a reflexive effect of allowing these planes to extend into and onto the gallery space itself.

The cantilever pipes, rich grey in color, add a linear element or framework, blending aspects of drawing with the activity of painting and sculpture. In terms of color, the paintings themselves are made up of a wide-ranging silver palette. This color spectrum is enhanced by brief explosions of primary or secondary colors, as when one section of pipe is painted a deep forest green or when a piece of horse's mane has a glob of cadmium red woven deep into it. These gestures are evidence of the artist's use and understanding of the physicality of paint and its relationship to a wide array of surfaces. The myriad of visual arrangements also directly transmit the distinct feeling of spiraling towards a new location or landing spot.

One such landing spot is a darkened cinema space within the gallery. We are drawn to it by the continuous rhythm of the soundtrack. Inside, a painting has been suspended in the middle of the room. Released from its historical host, the wall, it now appears otherworldly, with a strand of neon light set behind and away from the painting. What has previously identified itself as a window or sliver of light has now become an apparition and a relic, set a part and made supremely tactile by the void that surrounds it. As the viewer travels through the gallery, the act of allowing oneself to pay attention without actively seeking a goal seems the way to move forward. By so doing, the effect of feeling newly present, like we've just arrived somewhere, is produced.

This is the structure Rosy Keyser has built. Some of it, invariably, comes from chance and luck, but a great deal of it comes from perseverance, intellect, and attention to process. With her dedication to translating the elements of human experience into tactile forms, she offers us multiple opportunities to rediscover the world we are currently struggling through. In George Pendle's essay, the artist is quoted as saying, "Your barn floor is my cathedral." In viewing her exhibition *Distal's Musk*, it is as if we are looking at slices of sunlight cutting through weathered planks onto a barn floor, the yellow / white shafts of light illuminating, in immense detail, thousands of particles of dust emanating from the hayloft above, while an animal form we can't quite see crouches silently below in the shadows.

Symmes Gardner
Executive Director, Center for Art, Design & Visual Culture

114

81, 84 *Shadow Shod*, 2017
aluminum enamel, oil enamel, spray paint,
desert aggregate on linen; steel pipe
79 x 50 x depth variable

82 *Lunar Petroglyph*, 2019
aluminum enamel, oil paint, gravel,
mica on linen
14 x 10 1/16 x depth variable

86, 87, 89 *Suspender Animal*, 2019
acrylic enamel, aluminum enamel,
sawdust, suspenders on canvas;
steel pipe
79 x 50 x depth variable

90, 91 *Meanwhile the World Goes On
(Diptych)*, 2019
aluminum enamel, oil enamel, graphite,
sawdust on linen; steel pipe
76 x 106 x depth variable

92 *Narrow Grief*, 2019
charcoal, oil paint, spray paint on linen;
steel pipe
60 x 20

95 *The Wild Bunch (Protagonists That Didn't
Make It)*, 2019
acrylic enamel, aluminum enamel,
sawdust, horsehair on canvas; steel pipe
32 x 26 1/4 x depth variable

97 *Cygnus*, 2017
acrylic enamel, aluminum enamel, spray
paint, sawdust on linen; steel pipe
90 x 74 x depth variable

98 *Forecast Corpus*, 2019
acrylic enamel, aluminum enamel,
spray paint, sawdust, horsehair on linen;
steel pipe
76 x 34 x depth variable

99 *Longshanks*, 2019
acrylic enamel, aluminum enamel, sawdust
on plywood; steel kickstand
48 x 15 x depth variable

101, 103 *The Breath Highway*, 2019
acrylic enamel, aluminum enamel,
oil paint, spray paint, sawdust, mica
on linen; coconut
24 x 20 1/4 x depth variable

102 *Synth Grin (Body-to-Body)*, 2019
acrylic enamel, aluminum enamel,
sawdust, and suspenders on linen,
basket
36 1/2 x 28 x depth variable

105 *Apocalypse Porn*, 2017–2019
acrylic enamel, aluminum enamel,
oil paint, gravel, sawdust, cardboard
on linen
84 x 53 x depth variable

106 *Throatshelf*, 2019
acrylic enamel, aluminum enamel,
oil paint, spray paint, sawdust,
cardboard on linen; steel pipe
48 x 30 1/4 x depth variable

110 *Move Your Shadow*, 2019
gesso, aluminum enamel, sawdust,
and woven bag on plywood with
sports net, steel frame, and collage
39 x 26 1/4 x depth variable

Dimensions are given in inches.
Artworks courtesy of Rosy Keyser
Studio, Brooklyn.

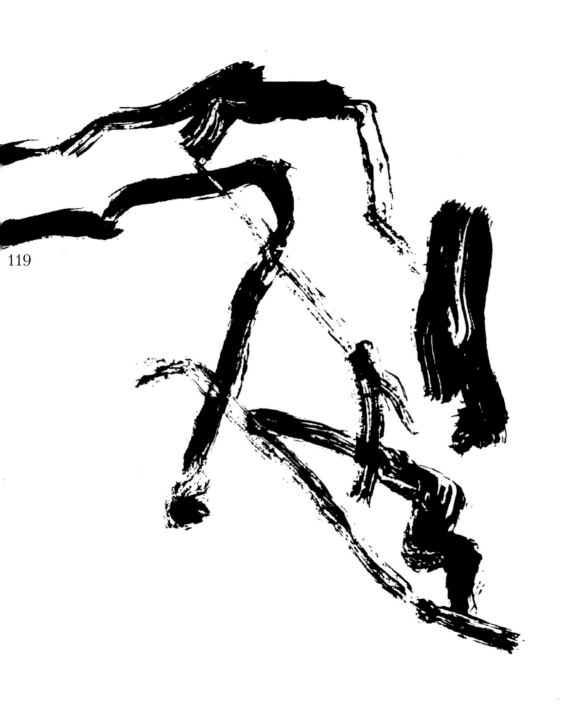

119

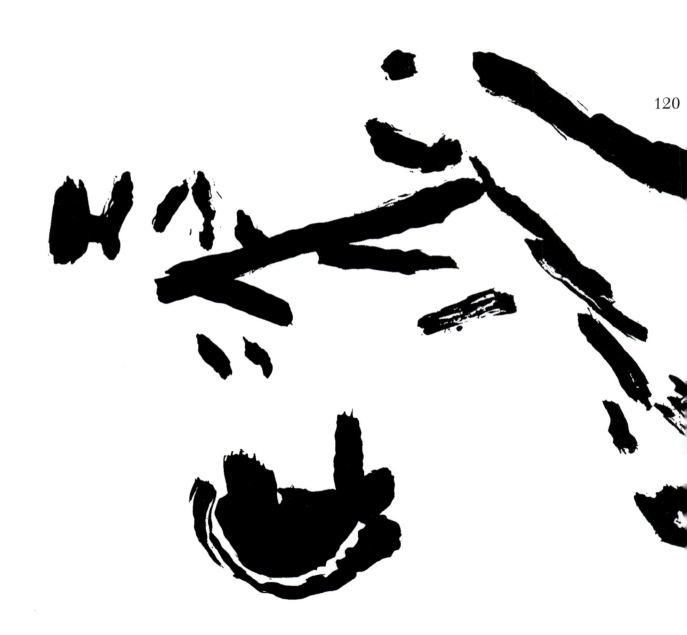

121

123

124

The presentation of *Distal's Musk: Rosy Keyser* at UMBC and this accompanying publication were made possible by generous support from the Maryland State Arts Council, funded by the State of Maryland and the National Endowment for the Arts, and the Baltimore County Commission on Arts and Sciences.

The essays contained in this publication are copyrighted by their authors. "Her Dark Materials: The Unsettling World of Rosy Keyser" copyright 2019 by George Pendle. "Being Brüt: Rosy Keyser's Cantilever Paintings" copyright 2019 Max Rosenberg.
© 2020 University of Maryland, Baltimore County

125

Library of Congress Control Number: 2019956122
ISBN 978-0-9600885-2-2

UMBC
Center for Art, Design and Visual Culture
1000 Hilltop Circle
Baltimore, MD 21250
cadvc.umbc.edu

Graphic Design: Francesca Grassi
Editor: Antonia Gardner
Exhibition Photography: Dan Meyers
Lithography: Marc Gijzen, The Netherlands
Printing: Benedict Press, Germany

126

This catalogue presents work from the exhibition *Distal's Musk*, which ran from October through December 2019 at the Center for Art, Design and Visual Culture at the University of Maryland Baltimore County. It also presents material studies and images that inspired the Cantilever Paintings shown in Baltimore as well as those that were exhibited earlier in New York, NY, Miami, FL, Marfa, TX, Austin, TX, and Portland, ME.

The exhibition would not have been possible without dedication and generosity of many. Indispensable to this exhibition is Symmes Gardner, Executive Director of UMBC's CADVC, whose broadminded support paved the way for this work to be shown in Baltimore, a city of great importance to me. To the dedicated team at UMBC, including Sandra Abbott, Mitchell Noah, Janet Magruder, Toni Gardner, Rahne Alexander, Monique Crabb, Safiyah Cheatam, and Sadaf Rehman, I extend deep appreciation for your time and assistance. Thank you to Dan Meyers for photographing the challenging landscape of Distal's Musk.

Thank you to Max Rosenberg and George Pendle for contributing thoughtful and insightful essays.

Tremendous thanks to Maya Barrera and Willie Gambucci, who kept a sense of humor while industriously and enthusiastically helping me wonder, make, and problem-solve both in the studio and beyond.

Thank you to Francesca Grassi, Paul Dally, Stan Narten, Erin Jones and Matt Dilling of Lite Brite Neon, Devin Toye, Matt Aselton, John Benson, Ken Farmer, Ryan Wallace, Jaime DeSimone, Erin Hutton, ICA Portland, Peter Blum, Simone Subal, Sarah Crowner, Anke Weyer, Esther Kläs, Thayer Porter, Gregory Sax, Dana Goodyear, Michele Maccarone, Ellen Langan, Lora Reynolds, Colin Doyle, Rob Weiner, Jenny Moore, Michael Roch, and the Chinati Foundation.

Britt and Wins, thank you for always keeping the light on for me.

Thank you to my parents for opening my eyes to the potency of nature and for showing me that beauty and uncertainty are as indivisible as tragedy and magic.